BOSTON

DAVID CUPPLEDITCH

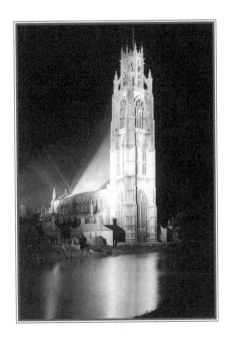

The
History
Press

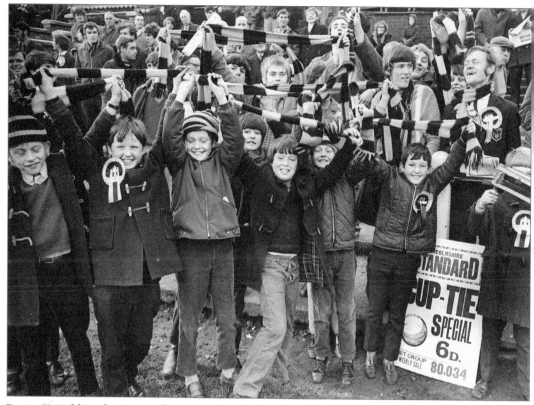

Boston United fans cheering on their team when United played York, December 1970.

First published in 1999
Reprinted in 2002, 2004
This edition first published in 2009

The History Press
The Mill, Brimscombe Port
Stroud, Gloucestershire, GL5 2QG
www.thehistorypress.co.uk

British Library Cataloguing in Publication Data.
A catalogue record for this book is available from the British Library.

ISBN: 978 0 7524 5368 2

Typesetting and origination by The History Press
Printed in Great Britain

CONTENTS

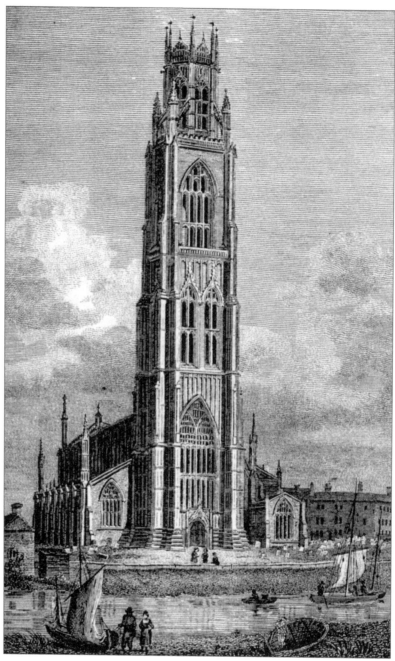

Before the advent of photography, the reproduction of visual images relied on prints and engravings. And Boston's share of engravings was second to none: they were plentiful and abundant, probably more so than any other Lincolnshire town. This was W. Burgess's drawing, in 1790, of the Stump, which was engraved a few years later by his son, H. Burgess. It shows the length of the nave and the library above the south porch, and boats being unloaded on the river. The latter practice ceased in the middle of the nineteenth century after indignant parishioners objected to this blatant commercialism on the doorstep of their house of prayer.

INTRODUCTION

In Domesday, which was compiled for King William the Conqueror at the end of the eleventh century, Skirbeck (now a part of Boston) is mentioned as having two churches – one dedicated to St Nicholas and the other to St Botolph. In 1066, the area we now know as Boston town was part of a much larger, straggling district with no central focus. It comprised mostly the lands of one of King William's most fortunate commanders, Wido de Creon (or Credun), in Wyberton, Frampton, Kirton, Fishtoft, Butterwick, Freiston, Bicker and Whaplode – Wido had no fewer than sixty lordships conferred on him in Lincolnshire alone. At this point in its history the area was a great deal more important than modern historians have generally indicated: this was one of the heartlands of the Danelaw, which stretched from Northumberland in the north to Essex in the south. The titles of many of the villages surrounding the modern town of Boston owe their origins to Danish Viking words or people. For example, Wyberton is named after Wybert of Wybert's Castle; Hubbert's Bridge derives its title from Hubba the Dane and Manwarings is also of Viking origin. The name of Skirbeck itself comes from skera, the old Norse for cut, and bekkr, the word for a swiftly flowing stream.

Because it was such a key area, religious houses were founded right across this part of England in an attempt to tame the unruly inhabitants. In those days clerics saw themselves as leaders of the community and they led by example, unlike some modern-day equivalents. The Franciscan, Dominican, Benedictine, Cistercian and Carmelite orders all built monasteries in and around Boston, as did the Austin friars. Theirs was an ordered society, built on discipline and honesty, and it influenced trade associations known as guilds (a Danish word), which left their stamp on records of the kind illustrated below.

During the Middle Ages, Boston's port was more important than London's. When King Henry II married Eleanor of Aquitaine, much French wine was imported through Boston (by 1301 the town had imported a total of 1½ million gallons of wine and royalty regularly passed this way. It was King John who granted the area of Botolphstown (or Boston) its first charter and this was not to be his only contact with the area. He had his fingers burned by the area's fiercely independent thanes

Seal of the Guild of the Blessed Mary, Boston.

Top: Seal of the Guild of St George, Boston. *Bottom*: Seal of the Guild of Corpus Christi, founded in 1335.

or overlords, lost his jewels in the Wash, but was also poisoned by the monks of Swineshead Abbey on 12 October 1216 – if Shakespeare is to be believed. (John died at Newark Castle, just over the border in Nottinghamshire, on 19 October.)

In the centuries that followed the area benefited from vast drainage works in the Fens, which turned flooded acres into fertile soil well suited to farming. However, in the seventeenth century Boston was severely affected by plague and a large proportion of its population died in the epidemic. Nevertheless, in the eighteenth century there was a resurgence of investment in the town, chiefly as a result of burgeoning trade, and a thriving waterway network was developed. A new Custom House had to be built in 1725 on the site of the old one at Packhorse Quay in order to oversee the growing export and import trade, much of it with the Hanseatic merchants of northern continental Europe. Then at the beginning of the twentieth century, Boston was badly hit by the decline of inland waterway transport, which had been overtaken by the railway. It also suffered an agricultural depression, the effects of which could still be detected in the town during the 1950s. However, by a stroke of luck Boston managed to save its railway station from Dr Beeching's axe and this may still influence its fortunes for years to come. The network in the middle of the county was decimated.

Boston is a town that has always seemed to be doing well until some unforeseen catastrophe has knocked it off track. Through this continual battering much of its ancient past, and, indeed, enthusiasm to record it, has fallen by the wayside. However, there have been some diligent observers of the area, such as Joseph Cooke, who was mayor of the town from 1902 to 1903. Cooke, who was born in Alford and trained as a journalist in Spilsby, eventually bought the old *Boston Guardian* and transformed the paper. It also earned him a fortune. The standard of journalism that Cooke set his staff was second to none and the *Guardian* soon attracted a wide readership. More recently, Richard Kay Publications produced their *History of Boston* series – a splendid collection of specialist booklets on various aspects of the town's past.

Photography has been a relatively new tool in recording Boston's history. Nevertheless, since the end of the nineteenth century the town's many photographers have created a unique visual chronicle of the area and on occasion have unwittingly give us an insight into Boston's remote and legendary past, a past which has often been clouded in myth, rumour and gossip.

SOME BOSTON
PHOTOGRAPHERS

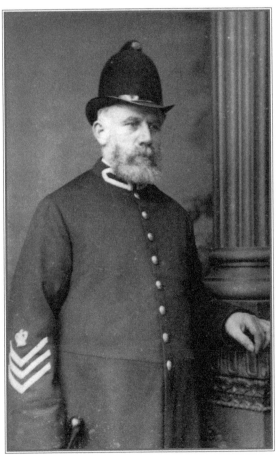

*Signor Luigi Cella, who lived at 9 Silver Street, had his photographic studio at 7A Wide
Bargate. This delightful portrait of a police sergeant (taken in about 1870) is an example of his
work. E.W. Peakome took over Cella's studio. Peakome in turn sold out to J.W. Thompson.*

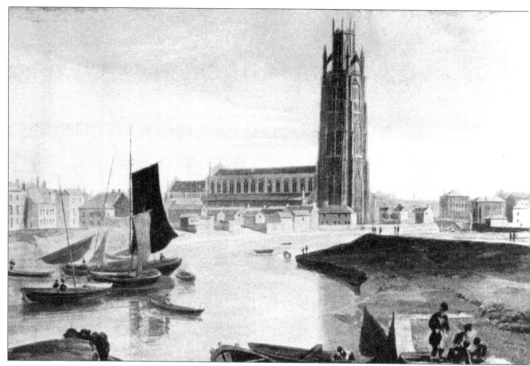

In the eighteenth century, people had to rely on paintings, engravings and drawings to reproduce the things they loved or treasured. This was the view of the Stump in 1822 before the Grand Sluice bridge was built with small fishing boats venturing up the Witham.

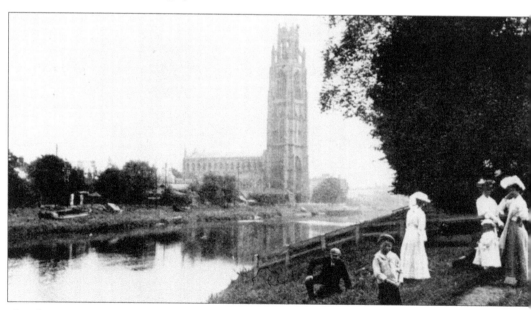

This photograph of about 1890 shows a similar view to that captured by the artist above. Photographer George Hackford was based at Ye Old Church Key, the house immediately opposite the porch of St Botolph's church. The building was in the Hackford family for generations and is currently being renovated (list and all).

Hackford's advertisement, stated that he established his photographic business in Boston in 1855. He was probably the first photographer to work the Boston area. His old studio was eventually taken over by Mary and Bess Bagley.

Caleb Chapman Smith had a studio at 39 Wide Bargate. Smith divided his time between Boston and Lincoln, where his studio was at 1 Norman Place as can be seen from this advertising card produced in about 1892. He used to commute via the River Witham and although he specialised in portraiture, he was also a dealer in photographic appliances.

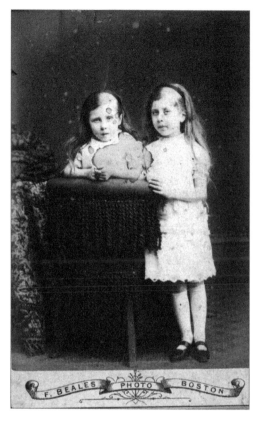

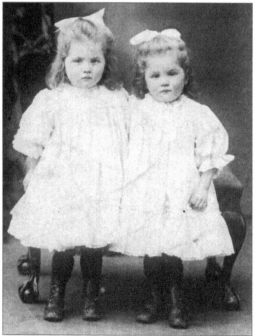

Above left: F. Beales was based at 31 High Street (the firm later becoming F. & G. Beales and incorporating premises 2 West Street as well).

Above right: This was one of F. Beales' cabinet portraits, *c.* 1895. In many old Bostonian family homes, there must be photographs like these gathering dust in old attics.

Left: Norah and Maude Salter (the daughters of Reuben Salter, see p. 124, photographed by F. Beales), *c.* 1909. One became Mrs Hoyles and the other Mrs Tryner.

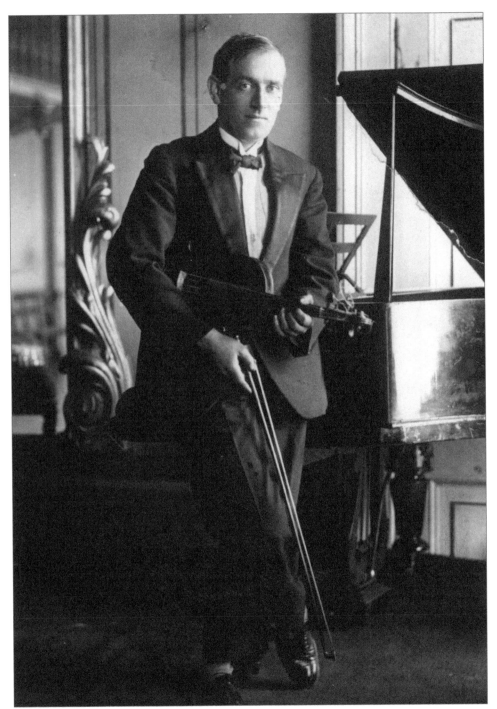

In 1919, George 'Fred' Addy purchased Thompson's studio at 7A Wide Bargate with his brother, Sid. They developed the business, moving to 9 Wide Bargate in 1925. This photograph of George Frederick Addy was taken in the Assembly Rooms during the twenties and shows him in his other guise of musician. He was an accomplished violinist and drummer.

During the twenties, Addys' studio relied solely on daylight to illuminate photographic sessions but then a generator was installed and it became one of Boston's first premises to have electric lights. It even adopted the name of 'Electric Studio'. This charming study by the Addy brothers was an early studio portrait from the new electric period. Fred and Sid used to cycle to commercial, wedding and portrait commissions over fenland fields and dykes with a half-plate camera and wooden tripod strapped to their crossbars.

This portrait was posed using a distinctively shaped stool as a studio prop. This stool is still owned by the Addys. Before the use of electricity, flash powder lit photographs but it could be a tricky commodity and occasionally it did not fire. One such failure happened during Lloyd George's visit to Boston station. Also, at official banquets in the Assembly Rooms, the powder was known to deposit nasty bits in the soup of diners, with the photographers scarpering and not being readmitted to functions.

In 1919, George Frederick Addy married Gladys Burton, of Nottingham (seen here) and, like so many other business folk, they made their home over the shop. George Addy was fortunate to return to Boston because many people who, like him, served with the Royal Flying Corps during the First World War were killed in action.

In this photograph Gladys is wearing her husband's old Royal Flying Corps coat and hat. Once again the stool (see p.12) features in the photograph.

Gladys and George's son Derek, who was born above the shop, is seen here at the rear of the business in about 1932. He has worked in and run the firm from 1946 up to the present day. In this yard rolls of film were pegged out on washing lines to dry in fine weather as they developed. These were the days before electric drying cabinets. But woe betide if it rained!

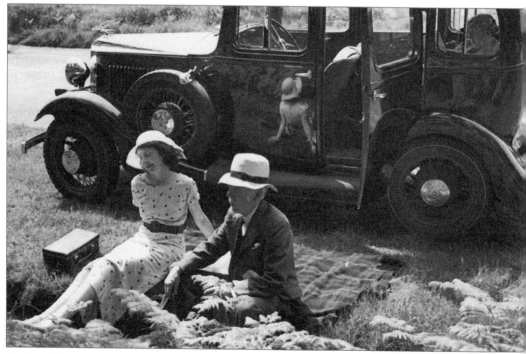

Gladys Addy and her father sitting outside their Vauxhall 14 car, enjoying the sunshine and a picnic, early 1930s.

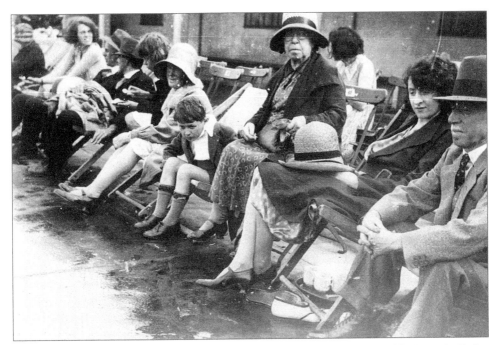

There were holidays to Skegness in the thirties. From the right here are Mr Addy (senior), Gladys Addy, Mrs Flory Buttery and Kenneth Bacon.

Fred Buttery, husband of Flory, who is shown in the previous photograph, helped with the construction of the Addys' printing rooms in the 1930s. Fred Buttery, who hailed from Rotherham, was a brass founder by trade.

"HOLIDAY SNAPS."

Please Remember
**OUR SERVICE IS THE
QUICKEST AND BEST**
ALL KODAK SUPPLIES.

F. ADDY, BARGATE, BOSTON.

This was an Addy's advert from the twenties or thirties; it reflects the tastes and styles of the period.

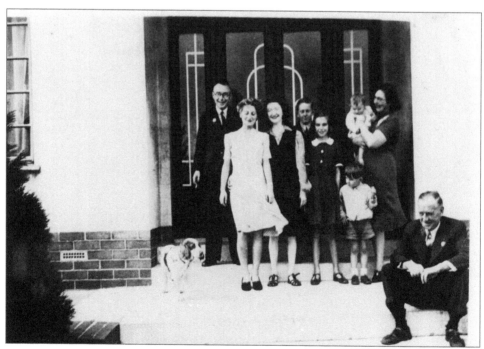

The family posed for a group photograph, 1942. Left to right: Nicky (the dog), Sid Addy (known better as 'Ruddy'), Irene his sister, Gladys Addy, Derek Addy, cousin Marjorie, Tony, Alice, holding the young baby, and Fred Addy, seated.

This Addy portrait is of David Bolland in 1943. It is a period piece: that knitted cardigan and Brylcreemed hair will bring back memories for people of a certain age.

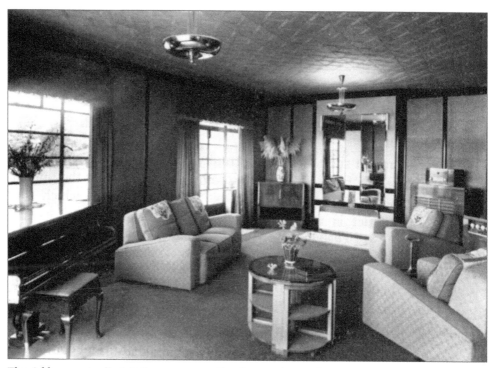

The Addys eventually left the room over the shop and moved to Bourne Court, Kelsey Bridge, Sibsey Road, Fishtoft. This is one of only a few art deco houses in Lincolnshire. The Addys moved into it in 1942. The interior was carefully designed to match the art deco style of the exterior.

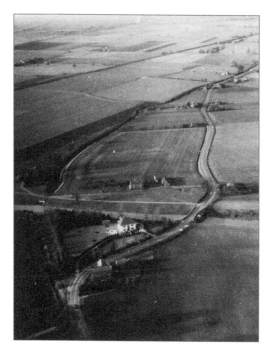

Aerial photograph of Bourne Court, Sibsey Road (in the centre), *c.* 1960. This view is typical of the Fens and shows why Bourne Court, like Boston Stump, was used as a landmark by RAF crews during the Second World War.

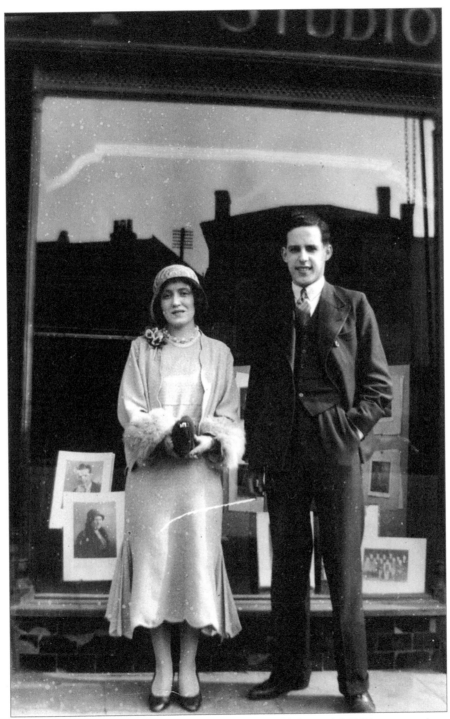

Between 1934 and 1975, the chief photographer at Addy's was Sid Phillipson, seen here in about 1933 with his wife, Maisy, outside Addy's shop in the Wide Bargate. Note the photographs of prominent Bostonians and groups in the window.

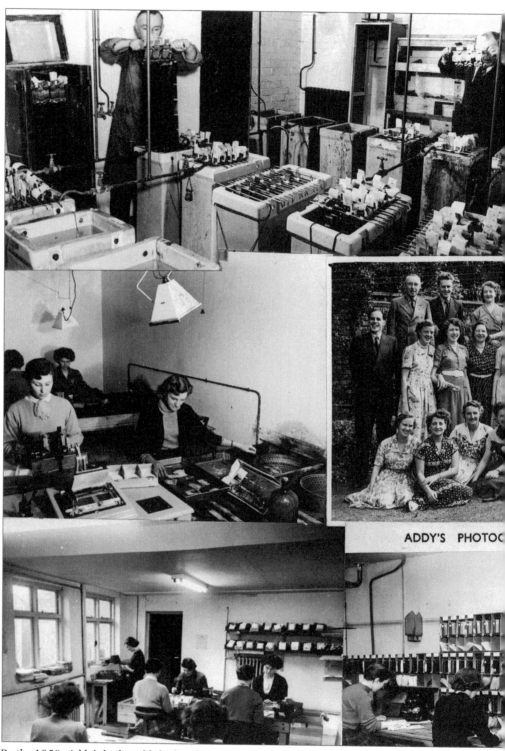

By the 1950s Addy's had established such a good reputation that it had trade customers stretching from

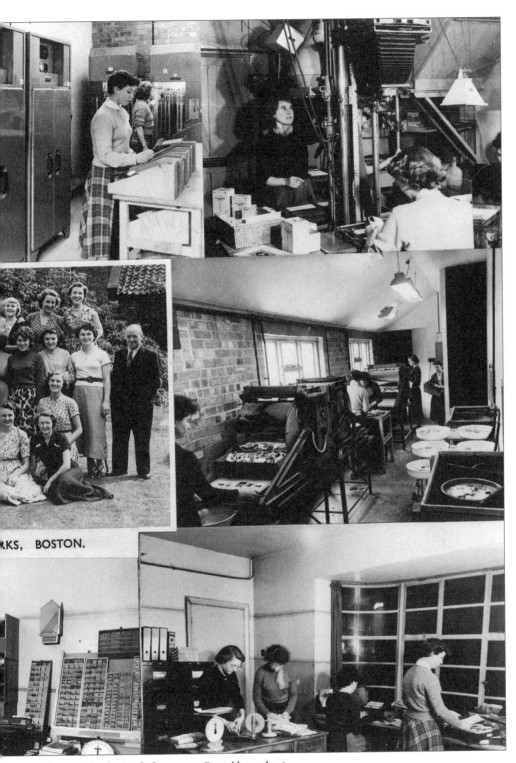

RKS, BOSTON.

Huntingdon to Grimsby (including seven Boots' branches).

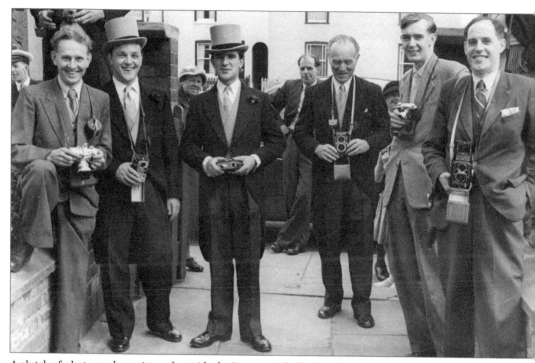

A clutch of photographers pictured outside the Roman Catholic church on Horncastle Road. They are, from left to right: Derek Addy; the groom and and best man (even they are holding cameras); Vernon Clarke, of Fisher Clarke (at that time the town's leading printer and manufacturing stationer), who was an excellent photographer in his own right and whose cine films helped to make up the popular video *Boston Looks Back*; Gary Atkinson, who worked with David Dunn and Nick Faulkner on the *Boston Guardian*; Sid Phillipson of Addy's.

For about ten years, Addy's incorporated an art gallery into their studio. They diversified into other areas, such as selling hi-fi and television sets, but these sidelines only lasted a short time. The art gallery soon attracted some attention, including that of an elderly couple who brought in a tired-looking watercolour. They exchanged their sad-looking work of art for something a bit more cheerful, accepting £25 for it in part-exchange. Addy's then passed on the watercolour to another buyer for £35. It turned out to be an original J.M.W. Turner, which eventually sold at Sotheby's for £15,000!

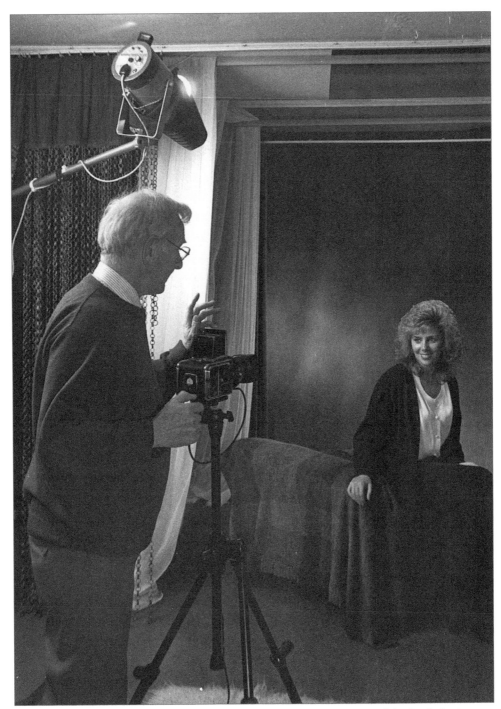

Derek Addy, seen here photographing a model in about 1997, has continued the family business to the present day. He wanted to be an architect in his younger days but instead was persuaded into becoming a photographer, winning the Kodak Gold Award for wedding portraiture in 1981 and several other regional awards since. This photograph was taken by Pat Banister.

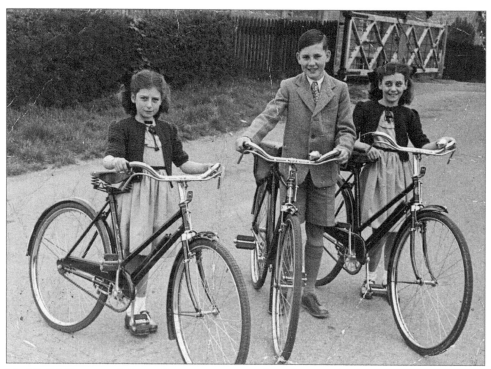

J.L. (Wally) Farram, of Queen Street, was yet another photographer working in Boston. This photograph of a group of children, with their bicycles newly purchased from Perkins' shop in Fydell Street, was taken near the Tattershall Road crossing gates. It is dated 15 May 1949.

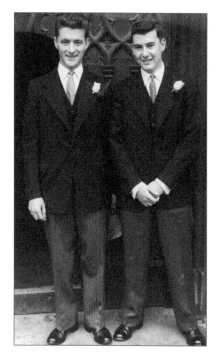

The other photographer in the town during the 1940s was Charles ('Chas') Faulkner, who recorded this wedding at St Botolph's in September 1957. The picture shows the groom, David Bolland, and best man, Jim Tryner (grandson of Reuben Salter, see p. 124). Charles Faulkner (1910–87), of Horace Street, started work as a journalist on the *Boston Guardian*. He joined the RAF during the Second World War and only turned to photography in the postwar period.

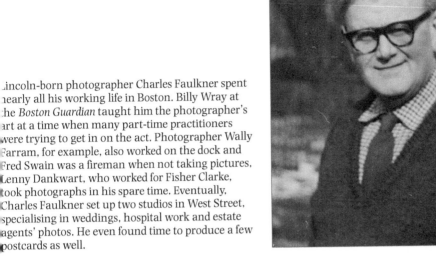

Lincoln-born photographer Charles Faulkner spent nearly all his working life in Boston. Billy Wray at the *Boston Guardian* taught him the photographer's art at a time when many part-time practitioners were trying to get in on the act. Photographer Wally Farram, for example, also worked on the dock and Fred Swain was a fireman when not taking pictures. Lenny Dankwart, who worked for Fisher Clarke, took photographs in his spare time. Eventually, Charles Faulkner set up two studios in West Street, specialising in weddings, hospital work and estate agents' photos. He even found time to produce a few postcards as well.

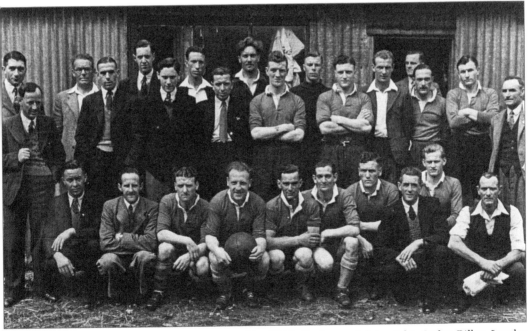

This Faulkner photograph shows Boston United in 1946. Back row, left to right: Ostler, Dilley, Luseby, Chapman, -?-, Elsom, -?-, McClure, Howard, Mick Joyce (in football jersey), Ted Eaglen (goalkeeper), Bill Pate, Dickinson, Sill Harvey, -?-, Roy Houghton and Bill Dickinson (trainer). Front row: Charlie Drury, Kent, Phil Bartley, Jim Harris (Captain, with ball), Harry Sharpe, Tom Mitchum, Harry Martin, Fred Tunstall (Manager – the ex-Sheffield and England player), Cook and 'Chinks' Howard.

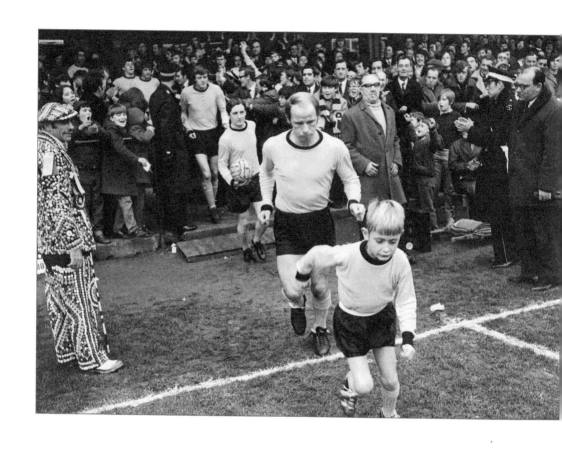

These images are two examples of Gary Atkinson's photographic work. (He is seen on p. 22.) They record the FA Cup fixture when Boston United played York on 18 December 1970. The team was led out by a young Jim Smith, who went on to manage Derby County and Newcastle United.

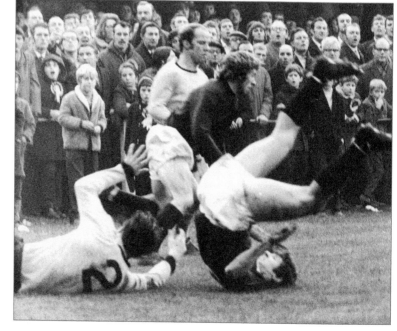

THE PORT

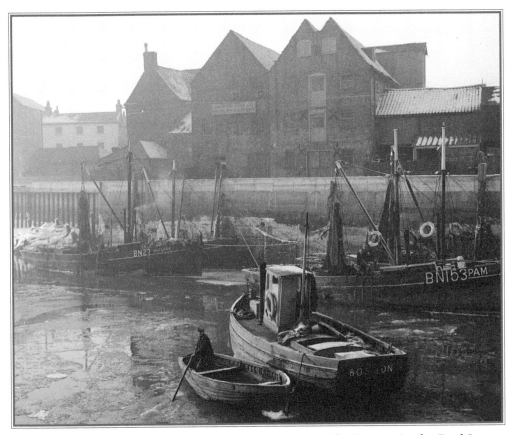

This was typical of the fishing smacks that went up and down The Haven at London Road Quay,
even in the fifties. Ice and slush are hampering the fishermen's work but at least the river has not
frozen over. The warehouses on the quay have now been demolished and a petrol station occupies
the site. The white-fronted private house and the Silt-Side-Service building on the left still stand.

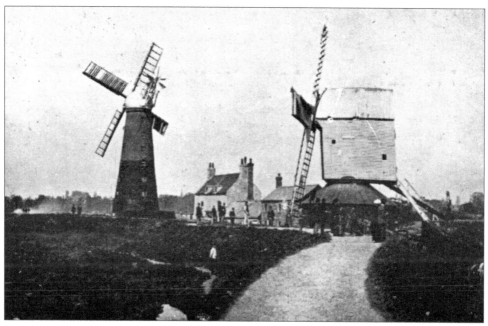

In 1881, an Act of Parliament authorised the construction of a new dock in Boston. The development of the site encompassed an area of just over 6 acres and involved the demolition of Fishtoft mill, Skirbeck mill and Mr Wrangle's post-mill.

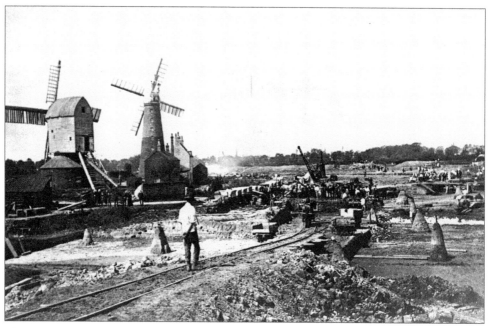

These three mills were sometimes known as the 'old Gallows Mills', because of the hangmen's gallows that stood for years near this spot. Two of the mills can be seen in this photograph taken as work began on the new dock.

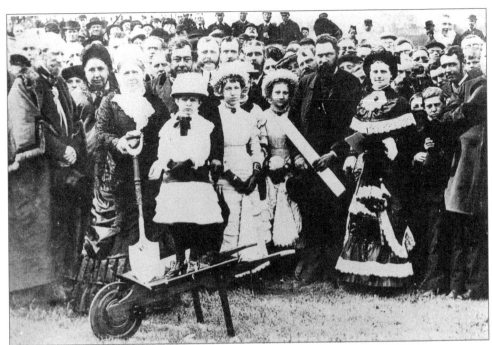

Mayor J. Simmonds and his wife cut the first sod of the new dock in 1882. William Wheeler (Borough Surveyor and designer of the dock with rolled up plans in his hand) looks on, together with the hordes of people who congregated for this special occasion. (Lincolnshire Library Service)

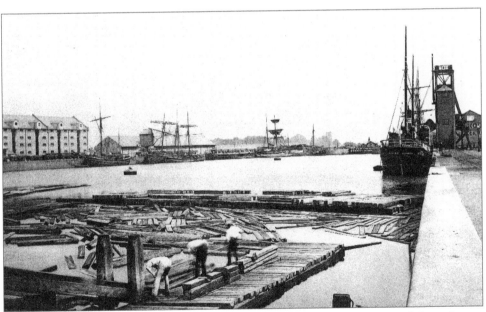

By 1884 the new dock had been completed, at a cost of £170,000. It had large bonded warehouses for storing tobacco, wines and spirits, two large granaries and a large coal hoist capable of shipping 1,000 tons a day. However, Boston soon became known as a great timber port, importing much of its wood from the Scandinavian countries.

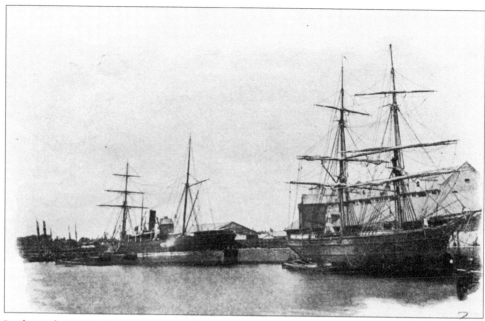

In the early 1900s, the ships that sailed in and out of the port must have made an awesome spectacle, inspiring many a young lad to look to the sea.

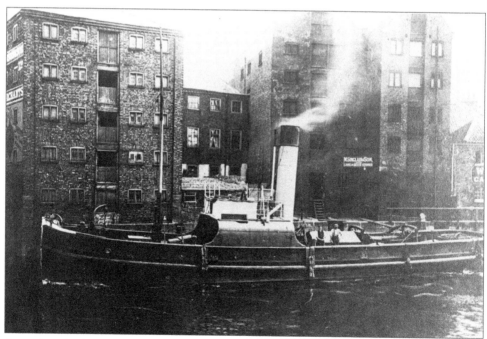

Steamships that have served Boston include the *Bulldog*, seen here passing W. Sinclair's warehouse. (Lincolnshire Library Service)

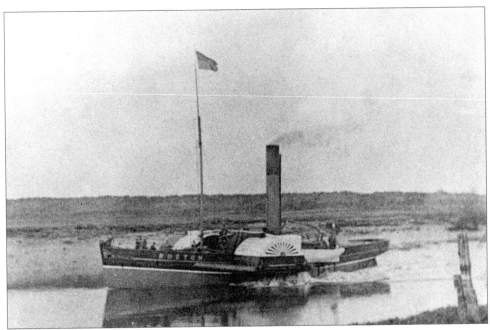

The original harbour steamer *Boston*, which made tidal and day excursions during the summer months, 1905. The steam-packet was photographed here on the Witham; it also doubled up as a tug. (Lincolnshire Library Service)

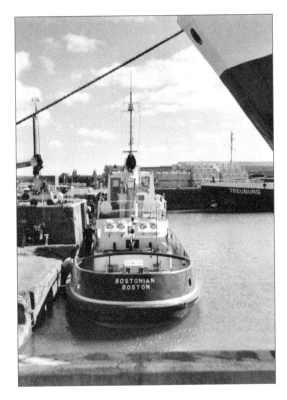

Its memory is commemorated in the present tug *Bostonian*, which operates out of the port today.

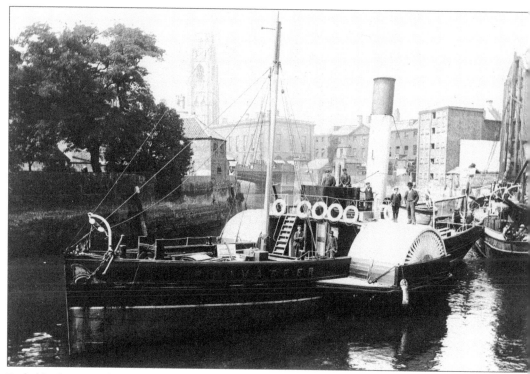

Probably the most photographed and picturesque steam packet was *Privateer*, seen here in about 1913 (Lincolnshire Library Service).

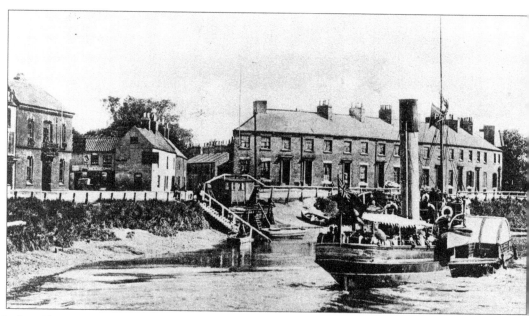

In fact, SS *Privateer* was so popular that this photograph was turned into a postcard. The crescent of houses behind is South Terrace and the road to the left of it runs down to the port. (Lincolnshire Library Service)

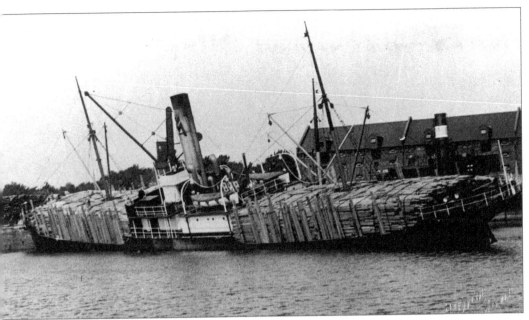

This timber vessel, seen in about 1921, has been loaded so enthusiastically that the ship has been left with a dangerously heavy list. In the early twentieth century, Boston imported timber, but also handled large quantities of coal for export – until the General Strike of 1926, which affected the port badly. (Lincolnshire Library Service)

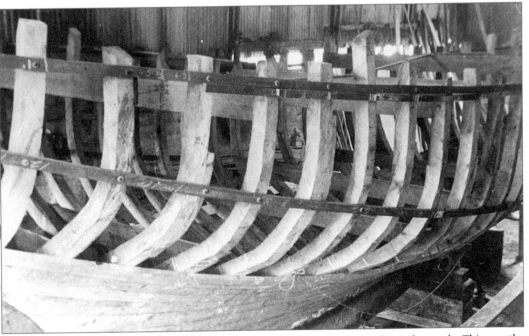

Boatyards, such as Gostelow's pictured here in about 1920, benefited from the timber trade. This was the hull of the *Chal* under construction. The Boston boatbuilder Mr Williams and his uncle worked here for many years.

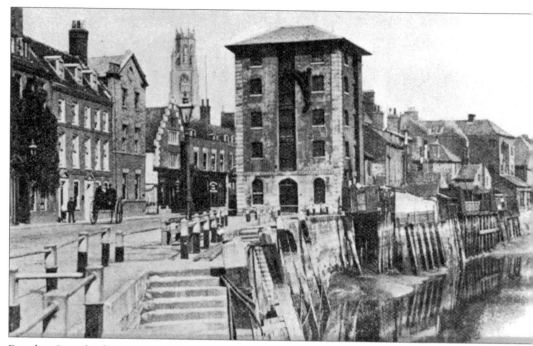

Doughty Quay, landing stage, High Street, with its quaint selection of warehouses and public houses just beyond, *c.* 1890.

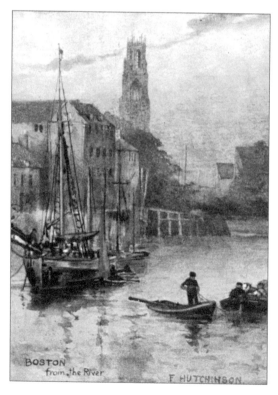

Since medieval times, shellfish boats have used the ancient wharves between the town bridge and Black Sluice. The small fishing vessels of Boston made such a picturesque scene that they were included in the J.W. Ruddock (of Lincoln) 'Artist' series in 1902. The company had produced over 400 views by 1907. This one, painted by F. Hutchinson, was printed in about 1904.

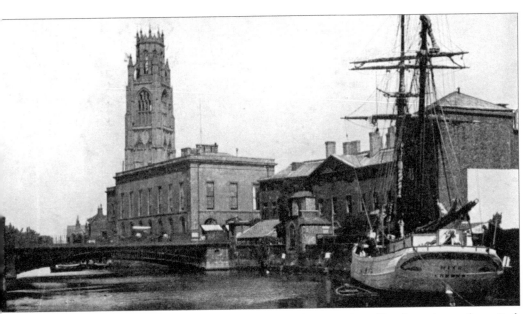

ailing vessels with fixed masts, such as the one seen here in about 1905, could only venture as far as Pack Horse Quay. Rennie's iron bridge prevented them from heading any further upstream.

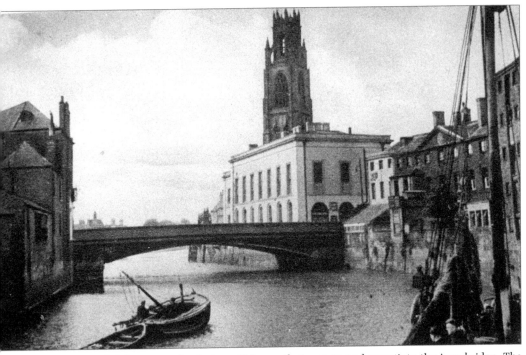

It was only the small fishing smacks that could lower their masts and negotiate the iron bridge. The schooner on the right of this 1919 picture could be the *Pearl*, which sailed out of Boston. Mr Newton of James Street was the skipper.

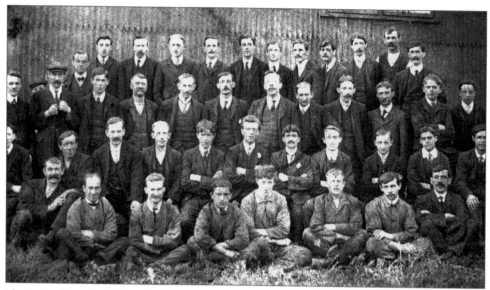

The Boston Deep Sea Fishing & Ice Company Ltd was incorporated in 1885 with capital of £60,000 in 6,000 shares of £10 each. The company comprised a fleet of trawl fishing smacks (steam and sail), together with a fish market, ice houses, workshops and offices on the Dock Quay. In 1894 when Cheyney Garfit, banker, was Chairman of the company, it had fourteen steam trawlers. This photograph of the workshop staff was taken in the 1920s. George Palmer (with cap and pipe), who died in 1932, was the Superintendent. Bill Barnett and Albert Meyer are also in the picture. Boston Deep Sea Fishing Company is no longer in Boston. Part of the company went to Grimsby and Freddy Parkes took the remainder to Fleetwood, Lancashire

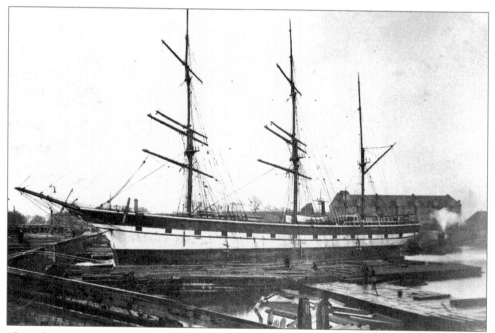

The *Ruby* moored in Boston port, 1913. (Lincolnshire Library Service)

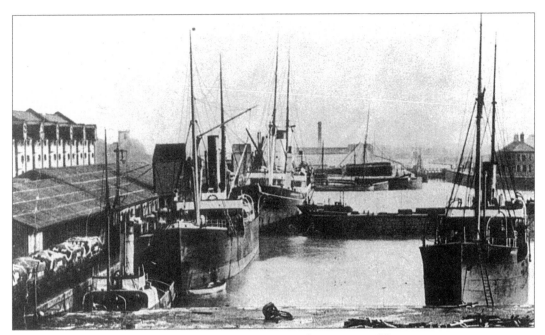

Even in the 1920s, when much sail had given way to steam, the port was still busy.

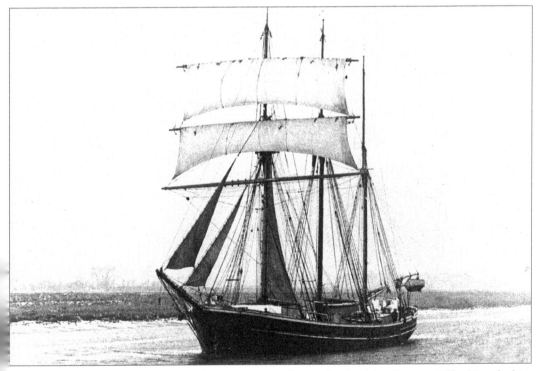

The last commercial sailing vessel to leave Boston Dock was the Danish schooner *Frida*. (Lincolnshire Library Service)

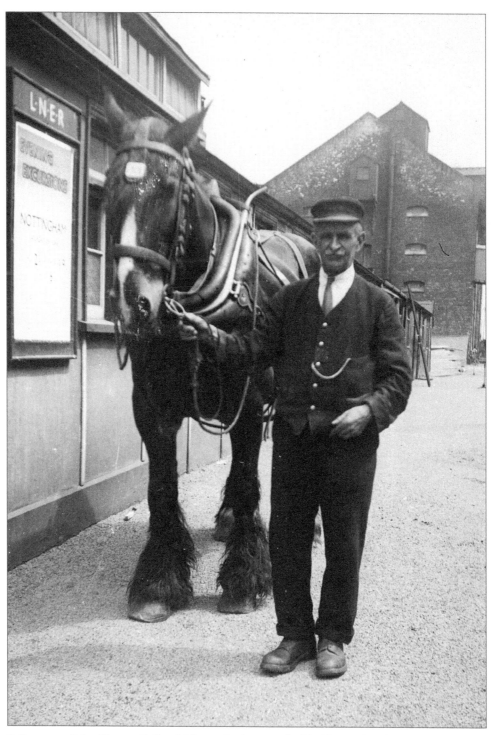

Railwayman John Thomas Bolland (shunter), photographed holding a dray horse, Boston Dock, *c*. 1930.

John Thomas's son, George Bolland (seen here on his twenty-first birthday) followed in his father's footsteps and also became a railway shunter. He lived in Tytton Lane. After he was diagnosed as having stomach ulcers he asked for lighter duties and became railway crossing-keeper at the Tattershall Road crossing gates.

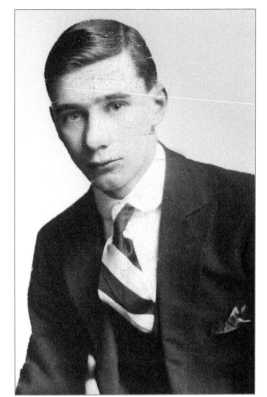

Just as many young boys went train-spotting in their youth, Boston's youngsters went boat-spotting and swimming – a dangerous pastime in the network of waterways and canals around Boston. This is a vessel some probably added to their 'spotted' lists: the sailing craft *Elenor* moored on the Witham, *c.* 1930.

The *Margaret*, with South Terrace in the background, *c.* 1930.

Radeance, with Bel Chambers at the helm, heading down the Haven, *c.* 1930.

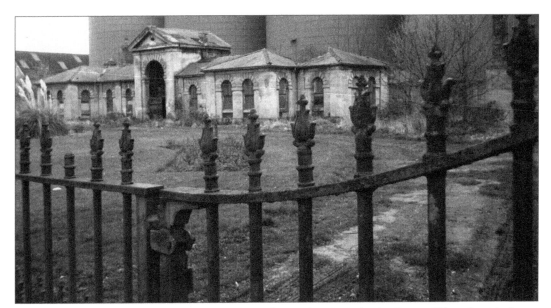

The old Lincoln Workhouse on Skirbeck Road was designed in 1857 by Sir George Gilbert Scott to house 300 paupers from 28 parishes surrounding Boston. The rear quadrangle was demolished in the 1980s when Boston Borough Council decided to build several large grain-drying silos on this site as part of the dock complex, which left only the front entrance (seen here) as a reminder of Victorian repression. The Heritage Trust of Lincolnshire plans to preserve the remaining structure.

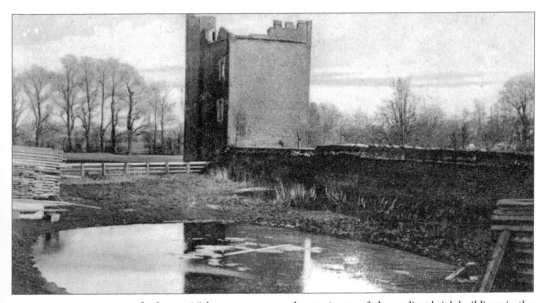

Hussey Tower, once part of a larger 15th century manor house, is one of the earliest brick buildings in the county and has been managed as a historical monument since 1996. Although looking forlorn and neglected in this scene, the Heritage Trust of Lincolnshire has made significant progress in its aim to repair, restore and develop the site into a tourist attraction and provide local residents and visitors with greater access to Boston's medieval past.

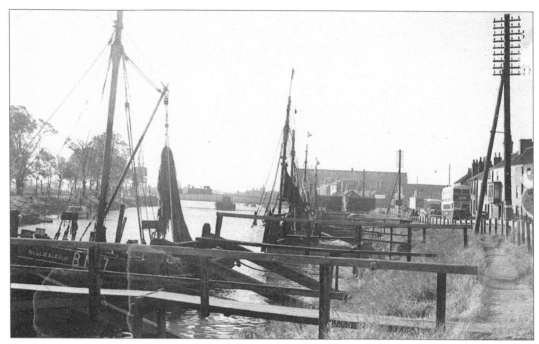

This pre-Second World War photograph of London Road Quay, shows the swing bridge in the background with a train going over it.

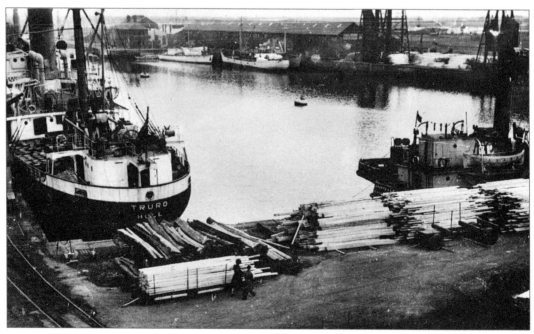

This corner of Boston Dock was photographed by Charles Faulkner, *c.* 1950. Timber was still an important source of income for Boston in the 1950s. The boat to the left is the *Truro* from Kingston-upon-Hull.

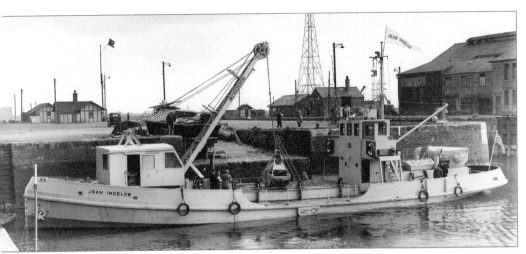

his Addy photograph shows the Boston dredger, *Jean Ingelow*, named after the famous Boston poet (see p. 62), (see p. 62) March 1950. There have been at least three dredgers employed by the Port Authority since then.

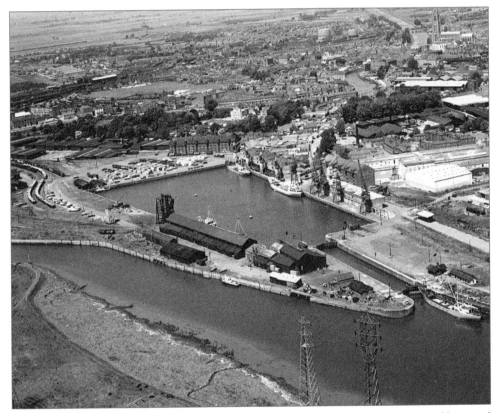

This view of Boston Dock shows the old Union Workhouse, on Skirbeck Road, the old coal hoist and many of the buildings that have since been demolished. Particularly noticeable are the electric pylons, erected in 1938. This photograph was taken in about 1951 when a second set of pylons was erected.

This Addy photograph of Boston Dock in about 1958 shows that trade was brisk in the post–Second

World War period.

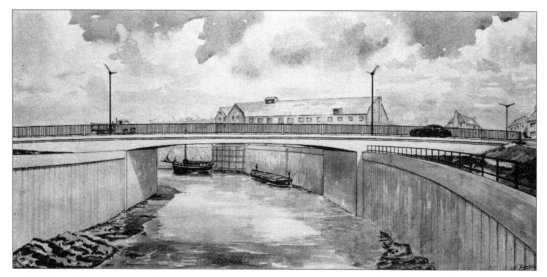

In the fifties, there was a notable increase in the amount of traffic passing through the town centre, which called for a bypass to be built (John Adams Way). This meant the erection of a new bridge. This was an artist's impression of the proposed Haven Bridge, drawn for Robert E. Earley and Partners of London, in 1964, which would skirt the town and divert the traffic away from central Boston.

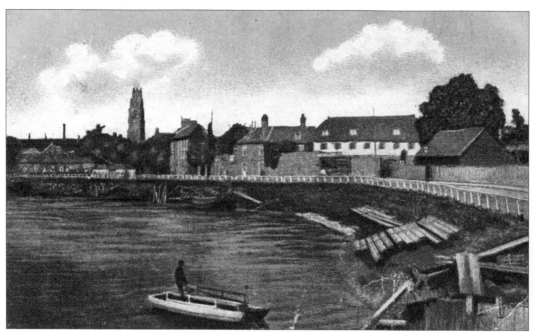

In days gone by the ferryman had transported traffic and people over the Haven, not far from where the proposed bridge was to be built.

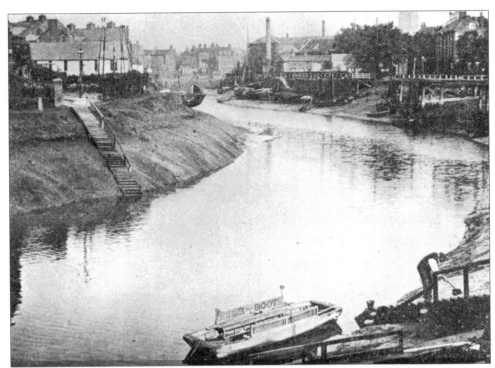

In fact, there was more than one ferry. This view shows the South Terrace–Edwin Street area ferry.

View from the dock, with grain silos just visible in the background. The ship taking on wheat is the *Claudia*, photographed in 1993.

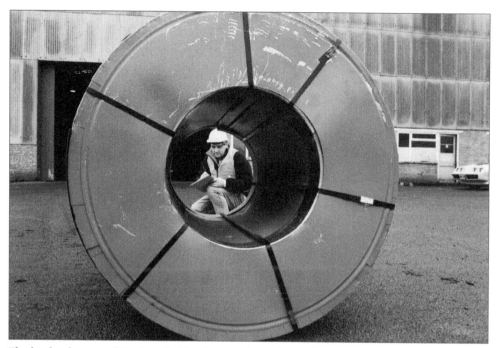

The kinds of commodities handled by the port have changed in recent times. This coil of steel, manufactured in France, is being checked by foreman Ivan Pearson outside one of the stevedores' warehouses on Boston dock before being transported to West Bromwich. Much of the steel transported through Boston is used in the manufacture of cars.

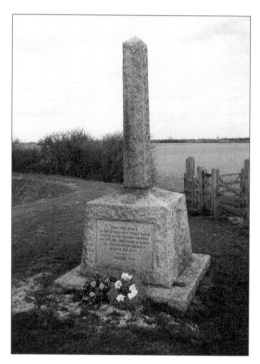

One of the most momentous occasions in Boston's history was the departure of a party of men who would become known as the Pilgrim Fathers. The group set sail from the Haven in 1607 for Leyden in Holland. These men, along with others, headed across the Atlantic for America on the *Mayflower* on 6 December 1620 and the rest, as they say, is history. This monument was erected in 1957 to commemorate their sailing.

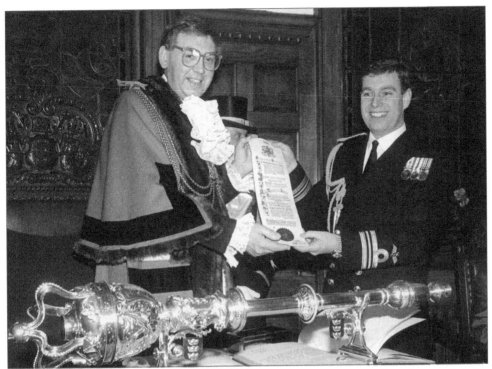

The Duke of York, HRH Prince Andrew, accepts an illuminated scroll recording the award of the freedom of Boston on behalf of HMS *Cottesmore* and her crew, from the Mayor of Boston, the late Keith Dobson JP, 1994.

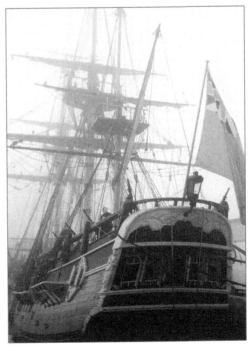

In 1997, HM Bark *Endeavour* (a replica of Captain Cook's ship) docked twice in Boston harbour, once on its way to Hull and again on its way back.

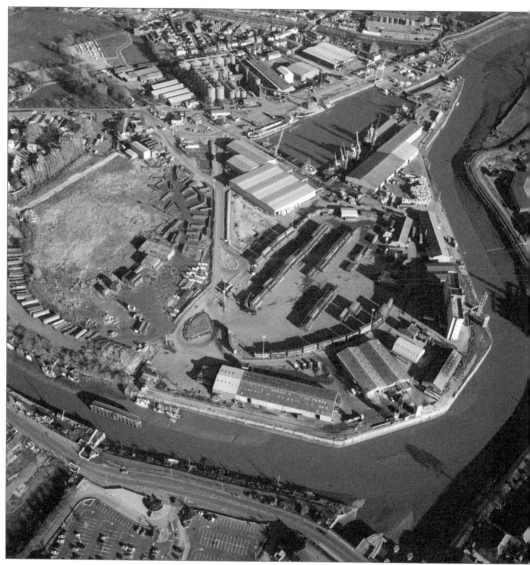

Boston port currently exports 300,000 tons of grain and imports about 300,000 tons of steel and 70,000 tons of paper a year. This aerial view of the dock and surrounding area shows the new paper terminal, (the long building, top right), steel terminal (just above centre) and container repair terminal (the long building, below centre). The port was privatised in January 1990.

OLD BOSTON TOWN

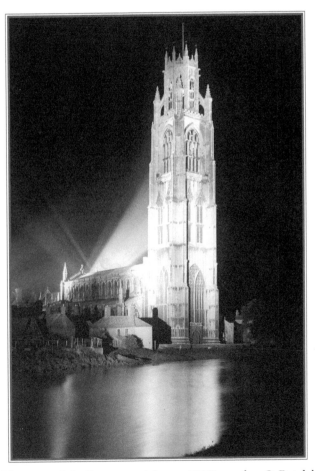

This wonderful picture of the Stump was taken on VE Day, when St Botolph's was lit by searchlights previously used to spot enemy aircraft.

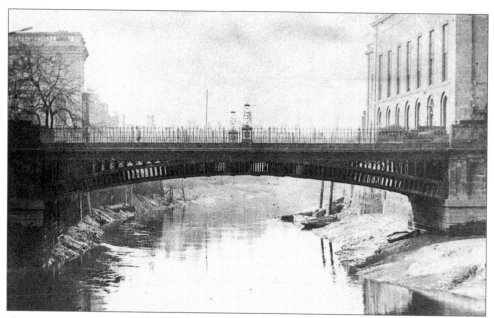

This was the first iron bridge over the River Witham and stood from 1807 to 1913. It was designed by Sir John Rennie, who also created the original Bargate Bridge and who achieved international fame as the designer of Waterloo Bridge in London. (Lincolnshire Library Service)

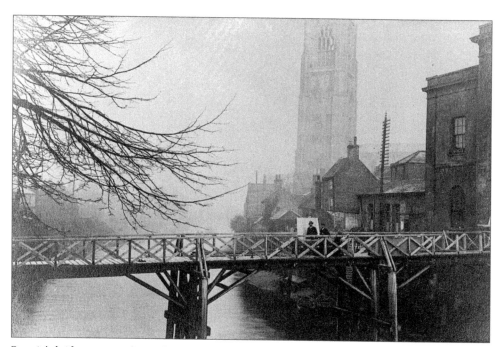

Rennie's bridge was condemned in 1912 as it was considered unsafe and the borough decided to erect a new one to a design by John J. Webster. A temporary wooden bridge for foot passengers was put up in order not to inconvenience the public while the new bridge was under construction.

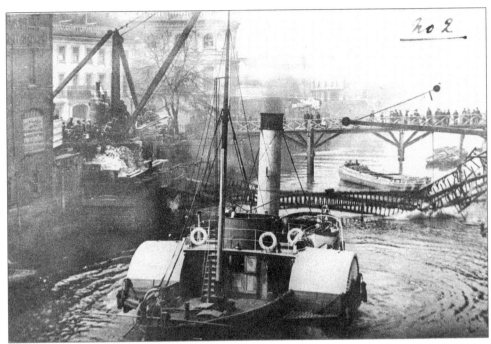

SS *Privateer* was employed to drag away the remains of the original iron structure. This friendly little tug was sunk off France in the early days of the First World War. The temporary bridge is visible in the background. (Lincolnshire Library Service)

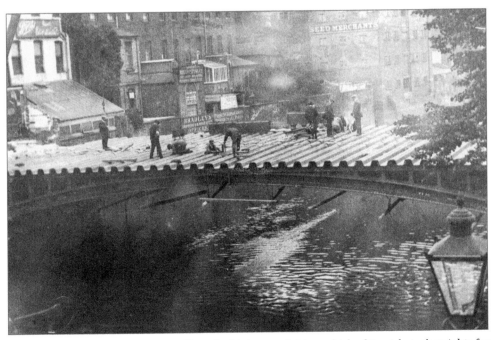

The welders and fitters worked quickly to build the new bridge, which ultimately took weights far in excess of those it was thought capable of bearing. (Lincolnshire Library Service)

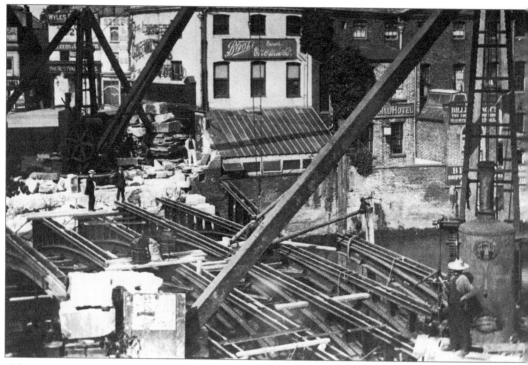

Elaborate poles had to be erected to cope with the weight of the iron girders. (Lincolnshire Library Service)

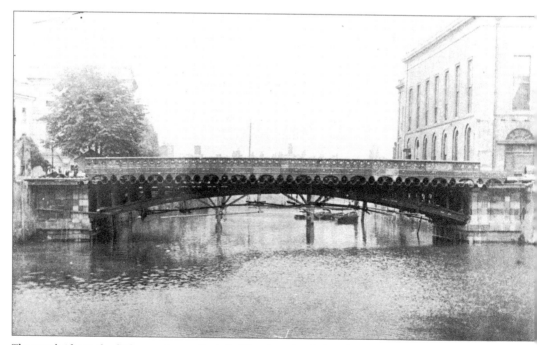

The new bridge took a little over six months to build and was ready by July 1913. (Lincolnshire Library Service)

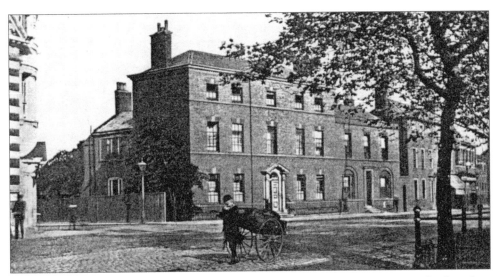

Park House, Wide Bargate (sometimes referred to as Tunnard House) was the boarding accommodation for Conway House High School. The Tunnards once owned nearly all of Boston and nearby Frampton. Tunnard House had large gardens, part of which later became Central Park. At the turn of the century, the Headmistress of the school was Miss Stothert and she lived here too. She was the daughter of the Revd S. Kelson Stothert, a Royal Navy chaplain at the time of the Crimean War (1854–6). He published an account of his exploits in *From the Fleet in the Fifties* (published by Hurst & Blackett in 1902).

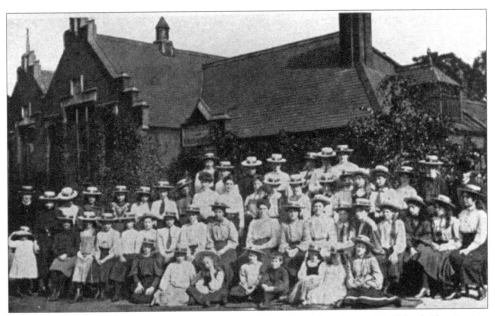

This photograph of Conway House High School boarders, by George Hackford (the Boston photographer, see p. 9) shows Miss Stothert, seated in the centre, without a hat. The school classrooms behind Park House, in Tunnard Street, where they remain to this day. After the death of Miss Stothert in 1919, other principals of the school included Miss Blight, Miss Clifton, Jean Kemp, Jill Nyman and the present Headmaster, Simon McElwain.

In 1996, Conway Preparatory School celebrated its centenary. Here we see a group of Year 4 pupils. The include Simon Radford, Thomas Cope, Thomas Ladds, Nicholas Rainford, Benjamin Needham, Pete Freeman, William Wrisdale, Tom Grundy, Benjamin Enderby, Myles Atkinson, Leo Stevens, Robert Morris James Glenn, Harriet Bambridge, Amelia Tunnard, Emma Pittendreigh, Alice Hardy, Rachel Grant, Laur Wrisdale, Sadie Sands, Elysia Mountain, Madeleine Hughes, Lauren Hartfil, Hannah Farman, Sara Cartwright, Samantha Turner and Laura Emerson, which comprise some good old Lincolnshire names.

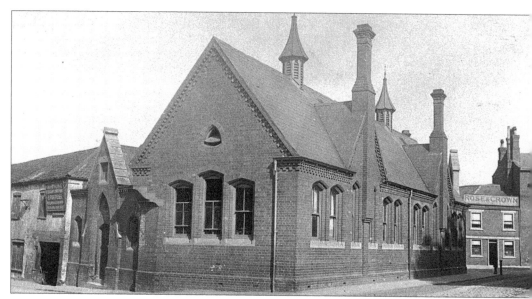

The Blue Coat School (founded in 1713) was originally intended as a mixed school, but in 1875, when the new building seen here was erected, accepted only girls. The boys, meanwhile, were sent off to Laughton School. The Rose and Crown pub can be seen on the right of the picture, which was taken in about 1909.

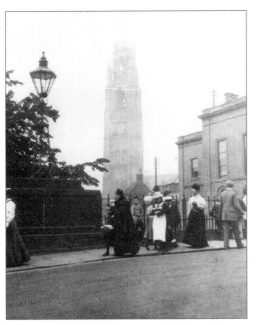

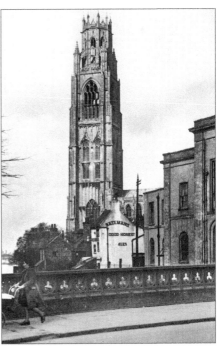

Gas lamp on Town Bridge, *c.* 1900. When this picture was taken there were about 350 street lamps in Boston operated by the old Boston Gas Light & Coke Company, whose headquarters were near Grand Sluice.

Compare this photograph taken by Charles Faulkner in the fifties with the one on the left. The scene has changed little.

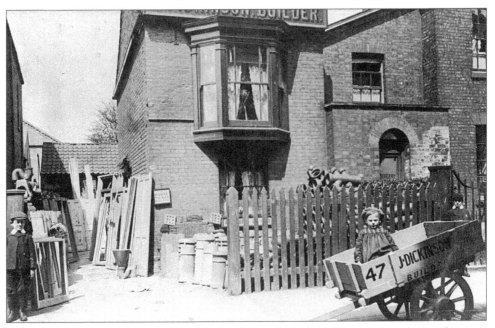

West Street, *c.* 1910. J. Dickinson's builders yard was situated on the site where the Regal cinema was later erected. The old Zion church was just off to the right.

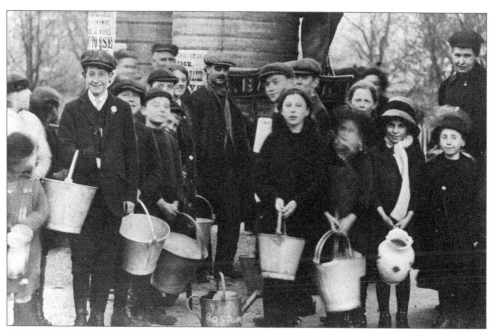

The provision of clean drinking water has always been a problem in Lincolnshire. When Boston's water supply became unreliable in 1914, the borough council decided to distribute clean drinking water around the town rather than risk a typhoid epidemic like the one that had affected Lincoln in 1905.

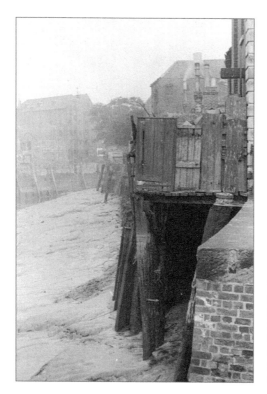

This snapshot, taken in about 1920, of low tide on the riverbank illustrates how the silt and mud provided a perfect breeding ground for germs in the days before modern sanitation was installed. Effluent was constantly discharged into the river, and if seepage got into the drinking water supply, it could spell disaster.

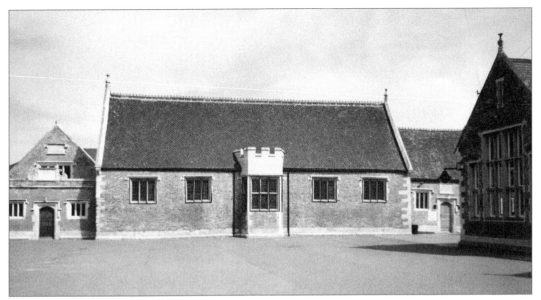

Boston Grammar School, founded in 1554, has enjoyed an excellent reputation. Vernon Howard, who lived at 18 Witham Place, was the art master here in Victorian times and his influence is still remembered to this day. This photograph, taken in 1999, shows the old original building. The academic standard at Boston Grammar is extremely high. Many ex-pupils have become respected Oxford and Cambridge professors and it has produced at least one Vice-Chancellor of Cambridge University in the Revd E.S. Roberts, who was also Master of Gonville & Caius College. More recently, Roger Budge (a name familiar to coal miners), the Bishop of Lambeth, the Rt Revd F. Sargeant, Barry Spikings, producer of the film *The Deer Hunter* and Len Medlock, the engineer, who is probably better known for his charity donations, have all been educated here.

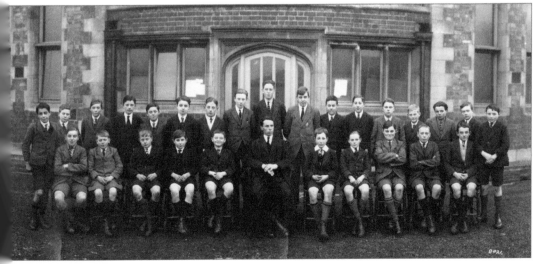

This group of Boston Gramma pupils was photographed in 1923 when the Headmaster was a young-looking Herbert Morris, who led the school from 1919 to 1950.

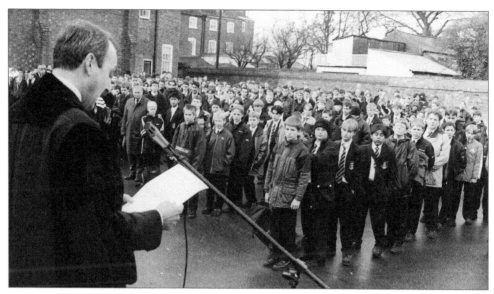

One of the enduring traditions of Boston Grammar is the annual Beast Mart proclamation, in the presence of the mayor and council and the masters and boys of the school. This usually takes place on 10 December and, in this photograph, is being carried out by the Chief Executive of Boston Borough Council. The charter of Queen Elizabeth I gave permission for a fair, or mart, to be held on St Andrew's Day (30 November) and for eight days afterwards. The Beast Mart is still proclaimed in the Grammar School yard but it has been many decades since cattle were last sold here. (The last shop in Mart Yard was demolished in 1758.)

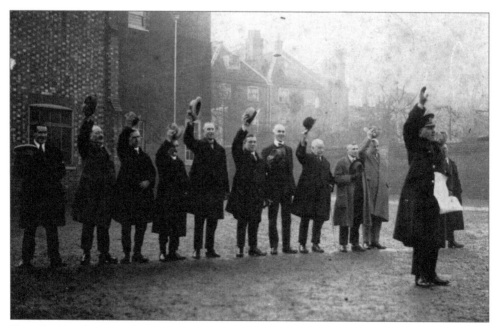

This photograph shows the borough councillors and mayor at a Beast Mart proclamation in the early 1920s.

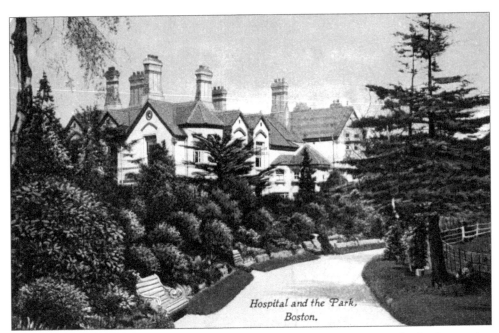

Hospital and the Park, Boston.

'People's Park', South End. This 33-acre plot was given to the people of Boston by the Corporation in 1871. Mr W.H. Wheeler laid out the pleasure gardens, which were planted with trees and shrubs. Cricket, skittles, quoits, croquet and football could be played here. The Boston Cottage Hospital, designed to accommodate people suffering from accidents or curable diseases, was erected in the park in 1874 – once again to plans by W.H. Wheeler. Miss Amy Johnstone was the Matron in 1894 and the hospital thrived until Pilgrim Hospital was opened in the 1970s.

Shodfriars Hall was a non-political club at the turn of the century with reading, billiards and smoking rooms for its 130 members. The building was erected in 1875 at a cost of £9,000, by architect J. Oldrid Scott, on the site of an earlier building. The existing building was given its present title because it was next to Shod Friars Lane, which itself refers to the Shod Friars (sometimes called Dominican or Black Friars), who once had a monastery on this site. The house that once stood on this site was once the home of Sebastian Cabot (1477–1557), the cartographer and son of the famous explorer, John Cabot, who discovered North America. Sebastian inherited the house, along with numerous other properties in England, on the death of his father in 1498. His widowed mother and two young sisters, Martha and Florence, also lived here.

61

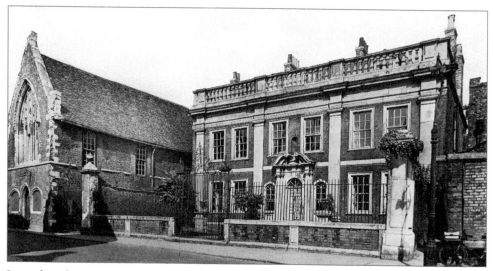

Just a short distance away are the Guildhall and Fydell House. The former was established in 1260 as the hall of the Guild of the Blessed St Mary. After the trade guilds were abolished, the hall was used as a civic centre for more than 300 years. Fydell House, next to it, was built by William Fydell, a prosperous wine merchant and Mayor of Boston. It was acquired by the Boston Preservation Trust in the 1930s and is currently the home of Pilgrim College (an off-shoot of Nottingham University). The American Room in Fydell House was opened in 1938 by Joseph Kennedy (father of John F. Kennedy) when he was the American Ambassador in London for the use of American visitors from Boston, Massachusetts.

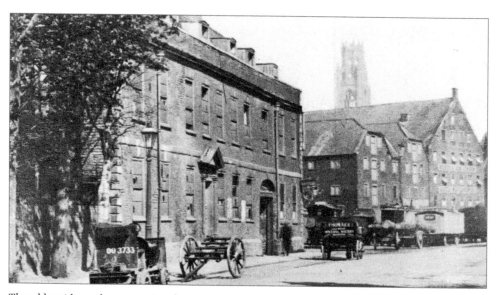

The old residence known as Ingelow House, now demolished, stood near the site of the house where Jean Ingelow (1820–97), Boston's most famous poet, was born. The first child of Boston banker William Ingelow, she moved to Ipswich and then to London, where she met many painters and writers. Her best known poem is 'The High Tide on the Coast of Lincolnshire', which was published in 1863 and which by 1879 had gone through twenty-three editions! The Jean Ingleow House was also used as a school for girls: the Principal was Miss Cecily Matthews. (Lincolnshire Library Service)

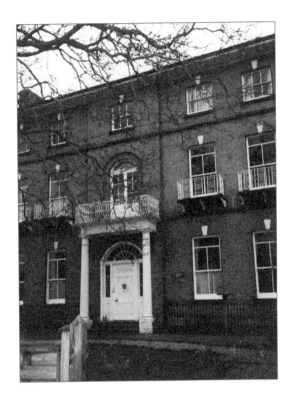

itham House, a fine example of Georgian
chitecture, was home of Mr O'Hara, the
ookmaker, but has now been converted into flats.
r O'Hara's brother Gerry directed the movies *The
tch* (based on the book written by Jackie Collins
id starring her sister Joan) and *Maroc 7*, among
hers. They were both sons of the late Major
'Hara of Main Ridge, Boston.

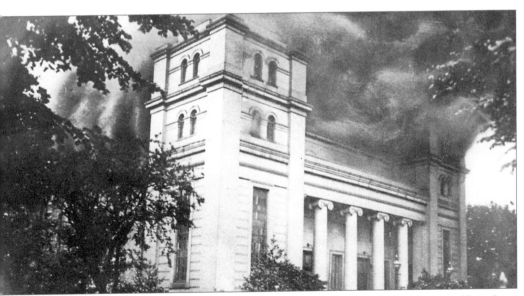

'here was a substantial Wesleyan community in Boston, as can be judged from the size of the old Wesleyan
'entenary chapel in Red Lion Street, built in 1839 and opened in 1840. It was capable of seating 2,000
eople, many more than the small original building in Wormgate where the Methodists first met. The rise in
opularity of Methodism in Boston was chiefly due to two ladies: Mary Wedd, who came to Boston in 1780,
nd Sarah Kirtwood, who arrived in 1795. Sadly, a five-hour fire destroyed the old Methodist chapel in Red
ion Street on 29 June 1909.

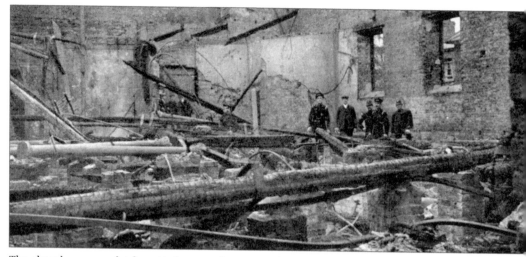

The chapel was completely gutted, as can be seen in this photograph of a group of men standing in th charred remains. An onlooker was to remark to the *Boston Guardian*: 'It was a splendid but awful sight.'

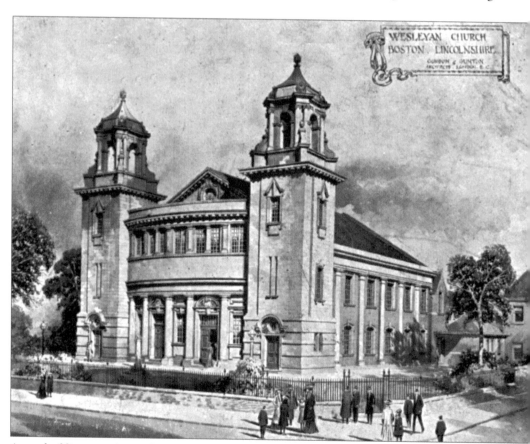

A new building, complete with two western towers and designed by Messrs Gordon and Gunton, was erecte on the same site and officially opened in 1911. It still stands.

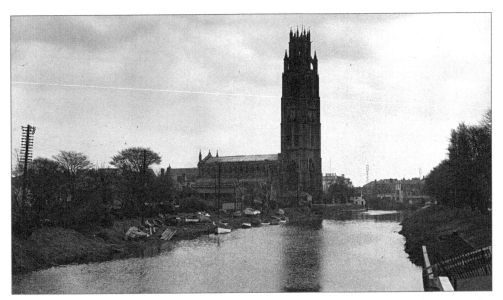

The glory of Boston is its 'Stump'. The 272 ft tower of St Botolph's church dominates the surrounding area like a beacon. This photograph of it looking rather dark and sombre, reflected in the River Witham, was taken in about 1952.

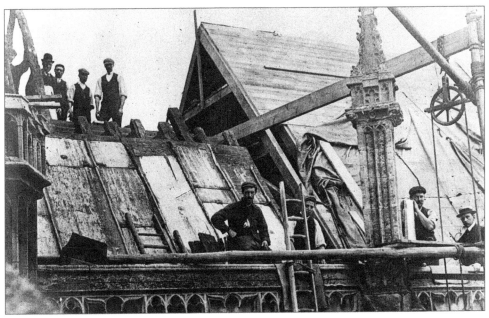

The upkeep of St Botolph's was a problem throughout the twentieth century. The chancel roof needed urgent attention in 1907 because of dry rot. The job was given to Samuel Sherwin & Son, of Wide Bargate. Sherwin lived at Thirkill House, Skirbeck. The old lead was stripped from the roof and the new timbers were inserted. Then the lead was recast in Church Close before being re-laid on to the new timbers. Harry Sherwin, Samuel's son, is on the extreme right of this picture in the straw boater and Tom Comer is the foreman in the boiler suit in the centre of the photograph. Comer's son became a schoolmaster at Tower Road School.

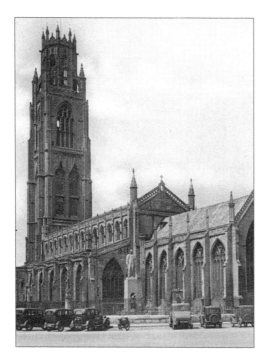

On a visit during the twenties, the antiquarian Sir Francis Fox expressed his concern at the state of the Stump. But it was not until 1927, when the roof began to show alarming signs of decay, that the architect Sir Charles Nicholson was asked to report on the condition of the structure. His conclusions sparked off a massive fund-raising exercise.

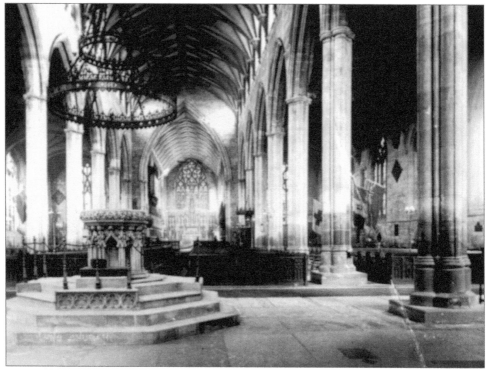

The old, vaulted wooden ceiling, which was found to contain death-watch beetle, can just be seen here.

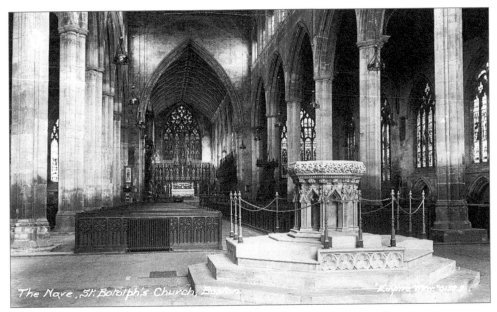

The Nave, St. Botolph's Church, Boston

At a cost of £23,000 it was replaced by the flat wooden ceiling that we see today.

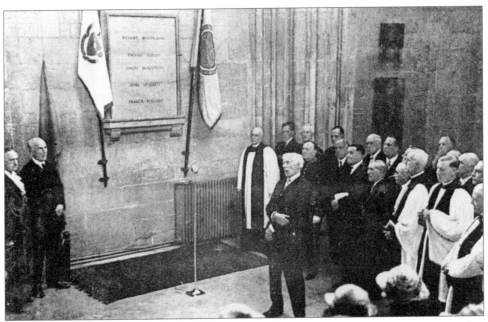

Mr Walter R. Whiting, representing the people of Boston, Massachusetts, was quick to respond to St Botolph's plight. He arrived in England with the gift of $55,000 (equivalent to £11,000) on an ancient silver salver, which he handed to the Archbishop of Canterbury on 8 July 1931 in the presence of the Bishop of Lincoln, the Dean of Peterborough, the Earl of Ancaster, Lord Brownlow and Mr Henry Dawes (private secretary to the American Ambassador in London). In return a plaque to Richard Bellingham, Thomas Dudley, Simon Bradstreet, John Leverett and Francis Bernard, who were all governors of Massachusetts, was unveiled in St Botolph's in 1936.

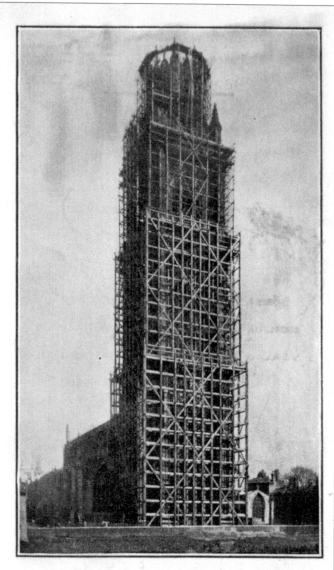

ST. BOTOLPH'S CHURCH, BOSTON,
LINCOLNSHIRE.

PATRONAL FESTIVAL.

Luncheon to the American Visitors
IN THE ASSEMBLY ROOMS,
St. Botolph's Day, 17th June, 1933.

Work then began on the restoration of the Stump and, on St Botolph's Day, 17 June 1933, there was a patronal festival followed by a luncheon for the American visitors, held in the Assembly Rooms, when Mr Walter Whiting was present once more.

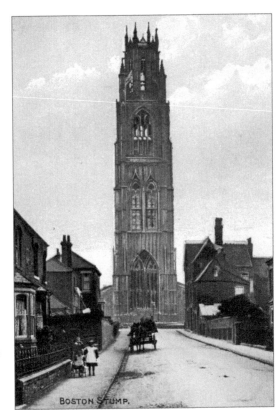

One of the most striking views of the Stump is from Tower Street, seen here in about 1905. Although this scene has changed little today, it is difficult to imagine that the river separates the Stump from the houses in this photograph. The image also emphasises the closeness of Boston to the effects of erratic tides. Benchmarks on the base of the Stump record the flood level tides on 19 October 1781, in 1807, 1810, 1953 and on 11 January 1978. Every time it is recorded, the flood level is higher.

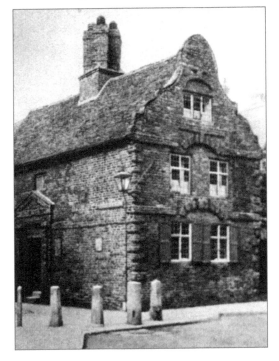

Next to St Botolph's is Church House, now part of the Blenkin Hall. (Blenkin was a curate at Navenby before being appointed Vicar of Boston in 1848, when the Revd J.F. Ogle retired.) This Dutch-looking building is said to date back to the time of Mary Tudor and appeared as a Dutch location scene in the wartime film *One of our Aircraft is Missing*.

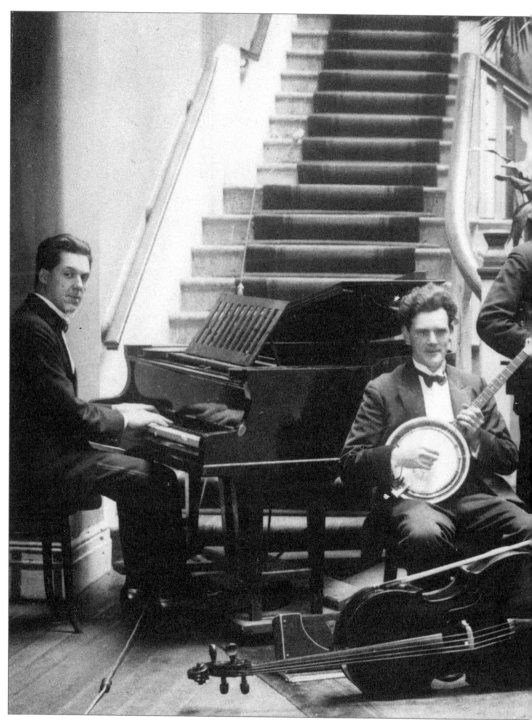

Boston's answer to the Palm Court orchestra was the 'Scala Theatre Orchestra' which used to play regularly between the wars. They are seen here in the foyer of the old Scala Theatre, at a time when Boston had the new Theatre and the Scala, and looking at the photograph you can almost hear the music

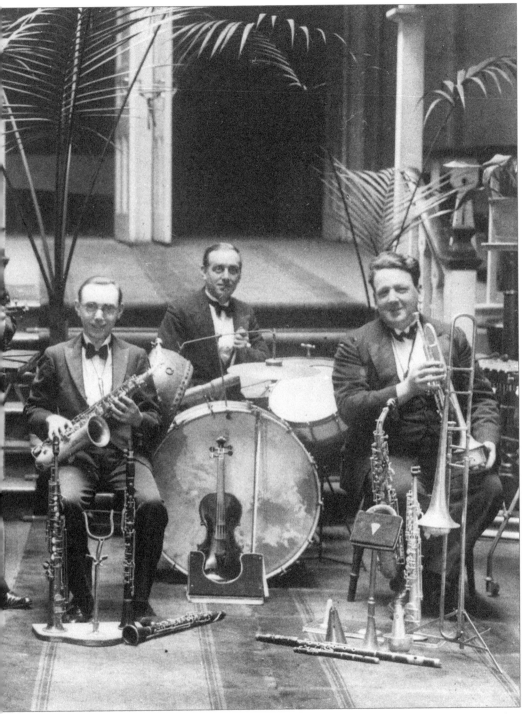

hey played. From left to right, they were Reg Latter (piano), Wilf Hastie (banjo), Alan Ainsworth (violin, vhose son founded the Alan Ainsworth Orchestra), Sid Addy (saxophone), Fred Addy (drums) and Harry ʾaine (trumpet).

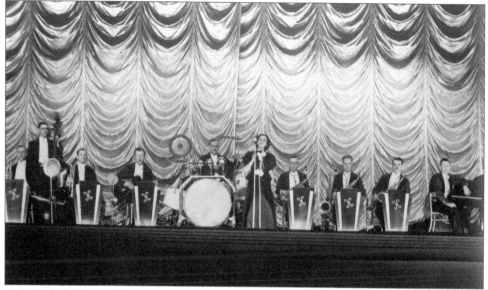

In the early days of the Second World War when things looked bleak, this was a morale booster at the Regal cinema. The group gathered here were rehearsing and comprised, from left to right, Walt Leabetter, Stan Wilson, Tower Godden, Percy Simpson (guitar), Fred Addy, Irene Addy (later Peck), Sid Addy, Arnold Foster, Jasper Sharp, Reg Latter.

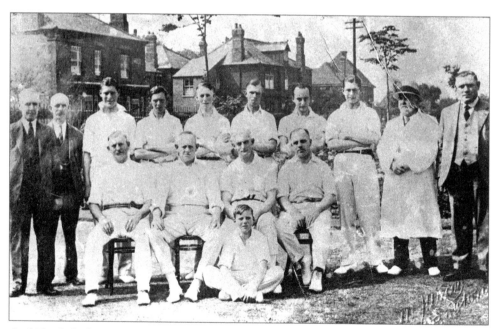

Cyril Bland, the famous cricketer, who played for Sussex and took all ten wickets in a match against Middlesex, can be seen seated second from left. He settled in Boston. This could almost be called Bland's team. The players, standing, from left to right, are Pat Bland, Jack Bland, Jake (or Wilfred) Bland, Harold Bland, -?-, Leigh Bland. Seated: a Bland brother, Cyril Herbert George Bland, another Bland brother, -?-. The small boy seated in front is Frank Bland.

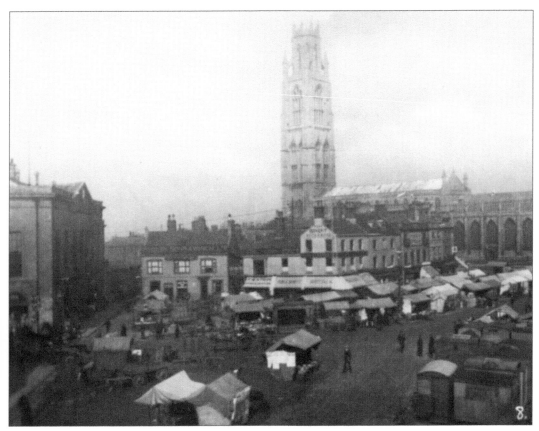

Boston became one of the chief corn markets in the country, see here in about 1920. Mobile huts were wheeled out by horse on market day and used by seed merchants until the 1960s.

There were many seed merchants in Boston, including W.W. Johnson (situated next door to Sinclairs), Ingrams (which was taken over by Sinclairs) and Hurst Seeds, which became Hurst-Gunson-Cooper and Tanber.

W. Sinclair, however, was probably the best known, the business being started by William Sinclair in 1850 and continued by his son, Charles. The latter, together with two members of the Clark family, financed a canteen (National Restaurant) for the Forces in 1940. During the Second World War, this non-profit canteen served literally thousands of meals to hungry servicemen. Charles was, in turn, followed by his sons (joint Managing Directors), Charles and William, until the firm was taken over by ICI in about 1980. The last William Sinclair, who died in 1970, used to be driven to work in a chauffeured black Lagonda! This advertisement is from 1954.

SINCLAIRS
FOR
Seed
Corn
AND
Fertilisers
You can count on QUALITY FROM

W. Sinclair & Son Ltd.
35 MARKET PLACE Tel 2434 BOSTON

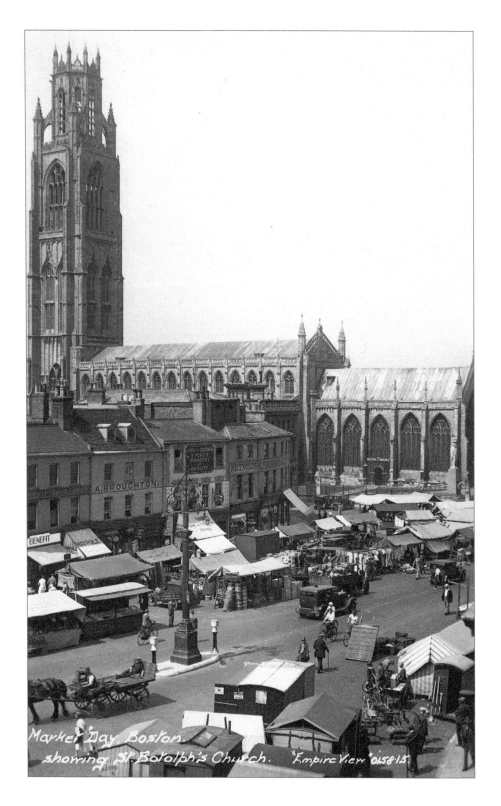

Market Day. Boston. showing St. Botolph's Church. "Empire View" 0158-15.

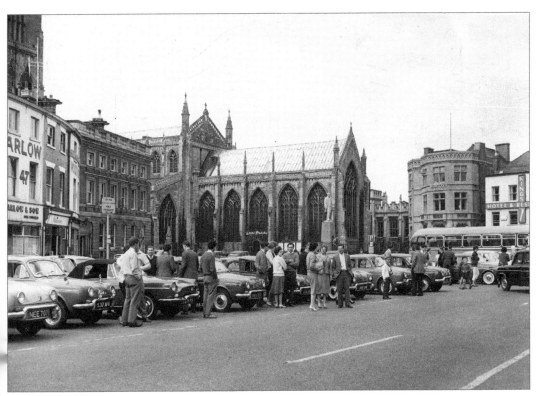

In 1962, the Renault Rally included a lunchtime break in the Market Place. Some of the cars (now classic models) and competitors were photographed on 5 May.

Opposite: Market day, Boston. Here it is possible to see the mobile huts mentioned on p. 73 more clearly.

In 1953, sandbags and extra fire brigade equipment were drafted in to deal with flooding which struck all along England's east coast. Everything came to a standstill and the emergency services were stretched. Norfolk Street and low lying parts of Boston were flooded but in comparison with the rest of the east coast, the town escaped lightly.

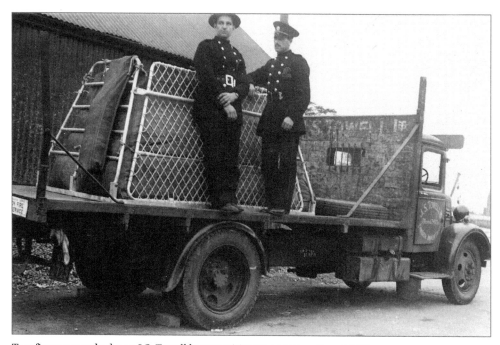

Two firemen perched on a J.S. Towell lorry, waiting to go into action, 1953.

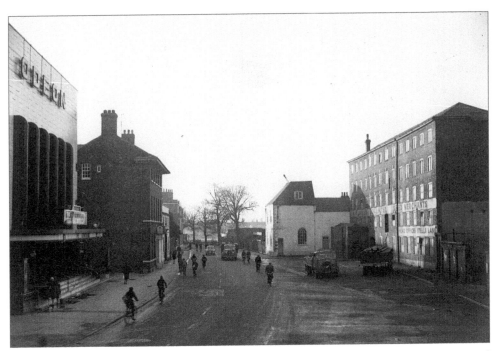

There were two cinemas in Boston in the postwar period, one being the Regal in West Street and the other the Odeon in South Street (seen here on the left) which was demolished in 1999.

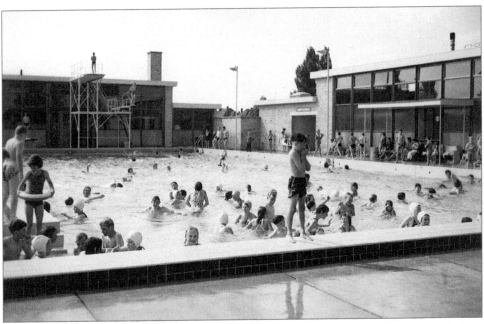

In 1963, Boston Corporation's long-awaited open-air, heated swimming pool was opened. After Mayor A.A. Goodson's speech, Councillor R.G.M. Moulder took the plunge along with a few hardy swimmers. The pool had cost some £50,000 and was long overdue.

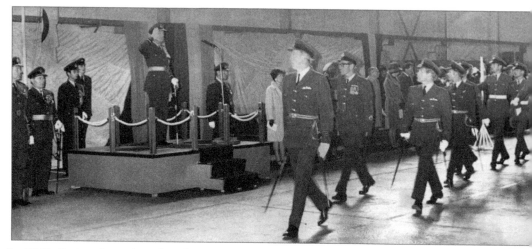

In 1963, Boston Council conferred the freedom of the town on Royal Air Force Coningsby. Relations between the town and the RAF station have always been good since the latter's inauguration in 1940. Building work on the aerodrome began in 1937.

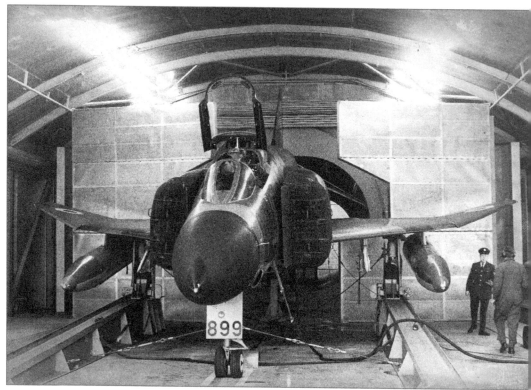

Throughout the Second World War, RAF Coningsby was a bomber airfield. It flew Lincolns for a short period after the war, then Canberras, Vulcans and even the ill-fated TSR2. In 1966, it became a fighter bomber base, with Phantoms introduced in 1967.

CHAPTER FOUR

SOME BOSTON
CHARACTERS

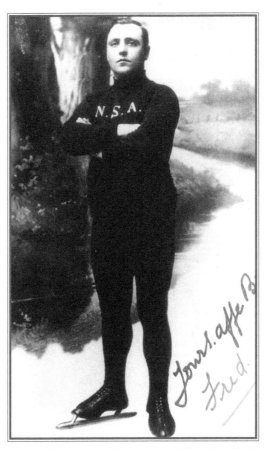

*Fred McGuire, the fen skating champion, c. 1910. Fred, followed in the footsteps of the brothers
Arch and champion skater, Fletcher. In the days when the Witham froze over for weeks in
wintertime, young boys would think nothing of skating up to Kirkstead and beyond, or on Bargate
Drain up to Frithville. Fred McGuire later kept the Axe & Cleaver pub in West Street, Boston.*

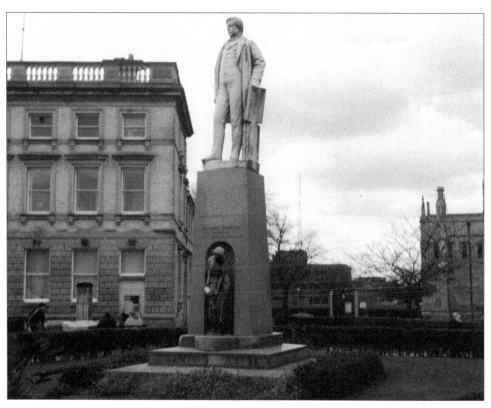

A Bostonian who made his mark in literary circles with pictorial journalism was Herbert Ingram (1811–60), who founded the *Illustrated London News*, the first paper of its kind, in 1842. After Ingram's death in a shipwreck on Lake Michigan, his body was brought home for burial. (His 15-year-old son, Hugh, also died in the same accident but his body was never found.) A statue to Herbert Ingram was erected in the Market Place and features one of his hands resting on a copy of the *Illustrated London News*. At the foot of the statue is a female figure, pouring water from an urn – indicating that Boston's plentiful supply of pure water was due to Herbert Ingram, who was responsible for having deep bore holes drilled under the town.

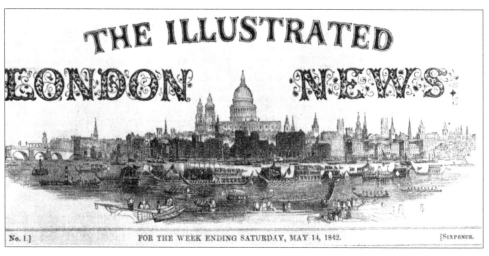

Ingram was uneducated and lacked literary ability, but he was an entrepreneur who made his first fortune from the sale of 'Parr's Life Pills' (the recipe of Dr Snaith, of Boston). When he arrived in London, he obtained the idea for his illustrated newspaper through Marriott, his business partner for a time, and found a good publisher in Joseph Clayton (the publisher of *The Spectator*, at that time the most important of the weekly newspapers in London). The *News* was an instant success.

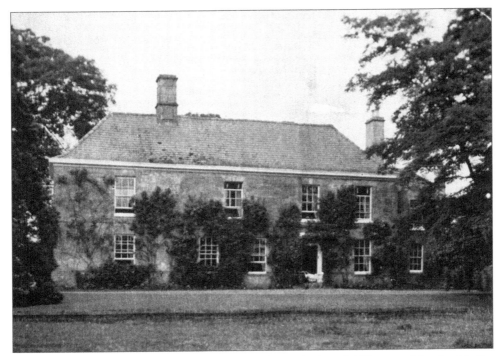

Herbert Ingram purchased Swineshead Abbey, together with about 2,000 acres of farmland in the Boston area, in the 1850s. He completely renovated the house at vast expense. The building had originally been built by Sir John Lockton in 1607 on the site of the old Cistercian abbey. Other improvements which Ingram instigated were the erection of a set of imposing wrought-iron gates at the southern entrance and a set of wooden gates at the western entrance.

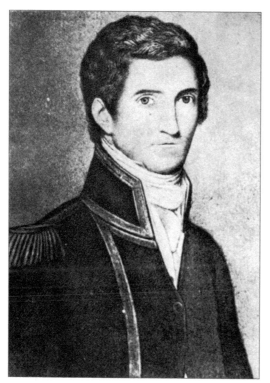

The explorer Matthew Flinders (1774–1814) was born at Donington, near Boston. He joined the navy in 1789 and served for a time under the infamous Captain Bligh and war service against the French when the French navy was defeated off Brest. He and George Bass (the ship's surgeon) then headed for Australia on the *Reliance*. In 1801–3 he was commissioned to circumnavigate Australia. Sadly, on his way back to England, he was imprisoned by the French in Mauritius, which wrecked his health before he was allowed to return to England in 1810. The Flinders Bar (a navigational aid), Flinders River in Queensland and the Flinders range of mountains in South Australia were all named after him. His only son, William (Matthew Flinders) Petrie became a well-known Egyptologist.

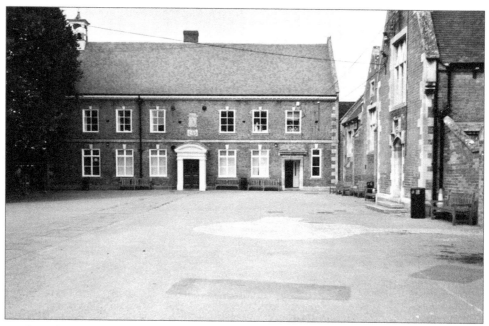

Matthew Flinders was educated at the Charity School, founded by Thomas Cowley of Wykes Manor House in 1701. This photograph was taken in May 1999. A tablet to Captain Matthew Flinders was erected in the chancel of St Mary's and Holy Rood Church in Donington.

All that is left of George Bass' (1771–1803) home is this plaque not far from the London Road Post Office. The famous explorer, who discovered the Bass Strait, lived in the premises known as the Crown & Anchor Tavern, or the Rope & Anchor Inn.

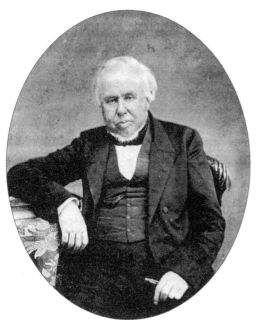

The Frieston-born historian, Pishey Thompson (1784–1862), photographed in 1857, just two years after the publication of his tome *The History and Antiquities of Boston*. He was a bank clerk by profession and a stickler for detail, who rose to become Secretary of the Smithsonian Institute after emigrating to the USA in 1818. On his return, he published his lifetime's research which has become the standard reference work on Boston. There is a brass plaque to Pishey Thompson in St Botolph's.

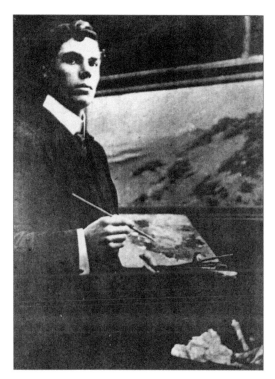

The artist W.B. Thomas (1877–1947) was born in Boston on 28 May 1877, the son of W. Thomas, the Boston architect, who designed the Fogarty feather factory in Trinity Street (surmounted by the well-known Fogarty swan). He spent a large part of his life travelling around Lincolnshire, recording the county's individual landscape in watercolour. Some of his landscapes were made into postcards.

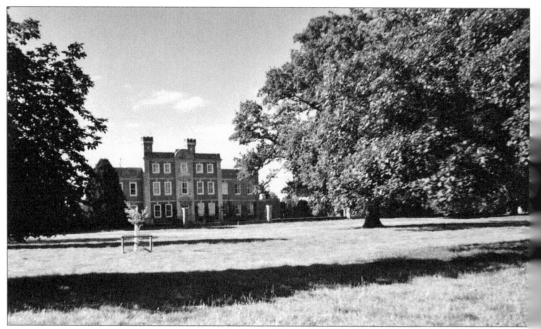

Frampton Hall is one of the most elegant houses in Lincolnshire. It was originally built for Coney Tunnard in 1725 (grandfather of the Samuel Tunnard who built Park House in Wide Bargate) and has been added to over the years. It is currently the home of Quentin Davies, MP for Stamford and Spalding. There are many Tunnard memorials in St Wulfran's Church, Grantham.

William Dennis (1841–1924) was born in Horsington, the son of a farm foreman. In 1861, he walked to Kirton where, with a bit of luck, a lot of hard work and much diligence, he amassed a fortune – chiefly by growing potatoes. In 1864, he married Sarah Ann Whitworth and they had five sons and four daughters. He was a hard but generous boss who looked after his employees and bought many acres during the agricultural depression. With his new-found wealth he funded the construction of Kirton Town Hall and largely financed the building of Kirton's Methodist chapel. In 1930, a bronze statue by Philip Lindsey Clark was erected outside Kirton Town Hall in his memory.

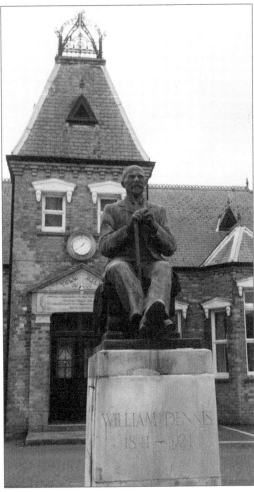

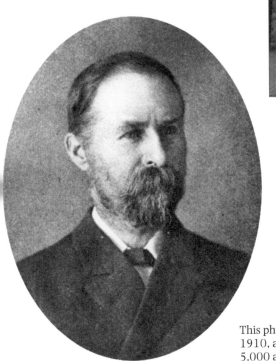

This photograph of William Dennis was taken in about 1910, at a time when he farmed between 4,000 and 5,000 acres in South Lincolnshire.

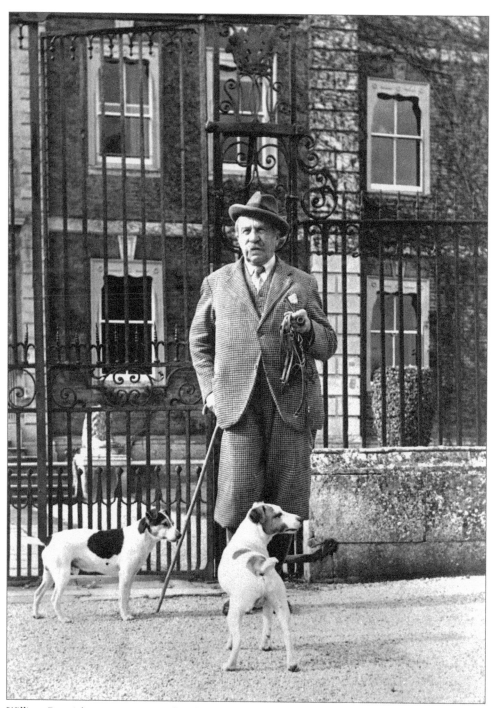

William Dennis' younger son Frank Whitworth Dennis (1878–1969), photographed here outside Frampton Hall, where he lived for fifty-four years. When the old borough decided to replace Boston's cobbled streets with tarmacadam, Frank Dennis purchased some of the cobblestones to line the floor of his stables.

The Lincolnshire photographer, Herbert Leslie Howe, was born in Boston in 1897 and sang as a choirboy in St Botolph's. He was the son of Henry Howe, an outfitter with Cheers. The family left Boston in 1908 when Henry Howe was transferred to manage the Louth branch of Cheers. This photograph of 'Les' Howe was taken in about 1905 in Boston. He is on the left of the picture.

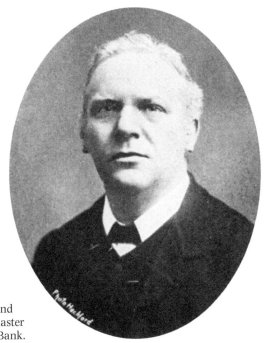

George Herbert Gregory (born 1853) was organist and choirmaster at St Botolph's from 1876 and music master at Boston Grammar School. He lived at 20 Witham Bank.

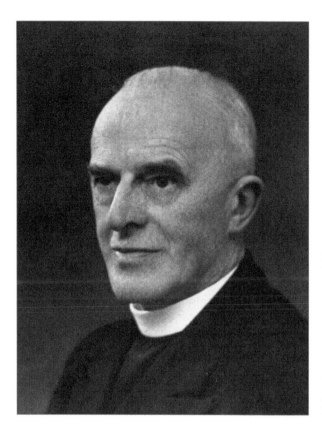

Canon A.M. Cook, Vicar of St Botolph's from 1931 to 1946. During his time in Boston he compiled *A Short History of a Great Parish Church and the Town about it* as well as *An Australian Boston, Boston Goes To Massachusetts* and *Boston Ballads*. There is a plaque to Canon Cook in Lincoln Cathedral. He used to love the 'Bug Fair', held every Monday on the Market Hill (it was the predecessor of present-day car boot sales), where all manner of curios and rubbish was put out for sale, and he frequently picked up the odd bargain.

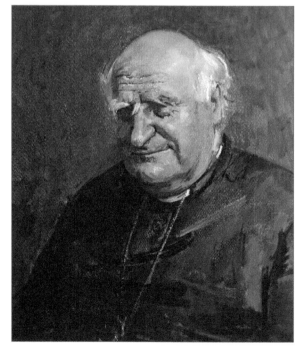

Between 1937 and 1939 the curate lecturer at St Botolph's was a young Michael Ramsey who went on to become a very popular Archbishop of Canterbury. This portrait of him by my old friend and one time drinking companion Ruskin Spear was completed in 1964 when the subject was known as the Rt Revd The Lord Ramsey of Canterbury. He blessed the studio before entering to have his portrait painted, and during the sittings used to hum hymns!

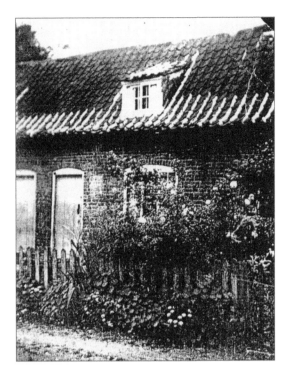

Undoubtedly the most famous, and certainly the most intriguing, twentieth-century character that Boston has produced came in the form of Old Mother Riley, alias Arthur Lucan, alias Arthur Towle. He was born in this Sibsey cottage on 16 September 1885, the Towle family moving to 10 Wood Yard, Boston, in 1891. (Wood Yard, together with Jail Lane, was later re-named Sibsey Lane.)

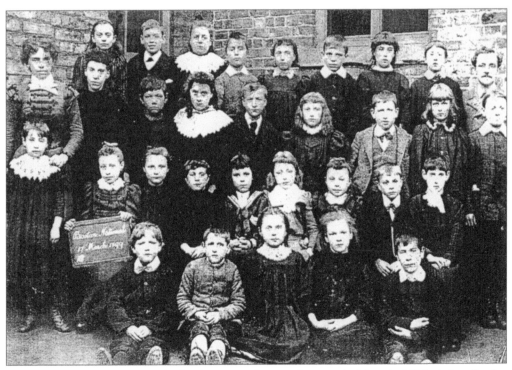

He attended the Boston National School in Pump Square, photographed here in 1899. Arthur Towle is standing second from the left on the back row.

89

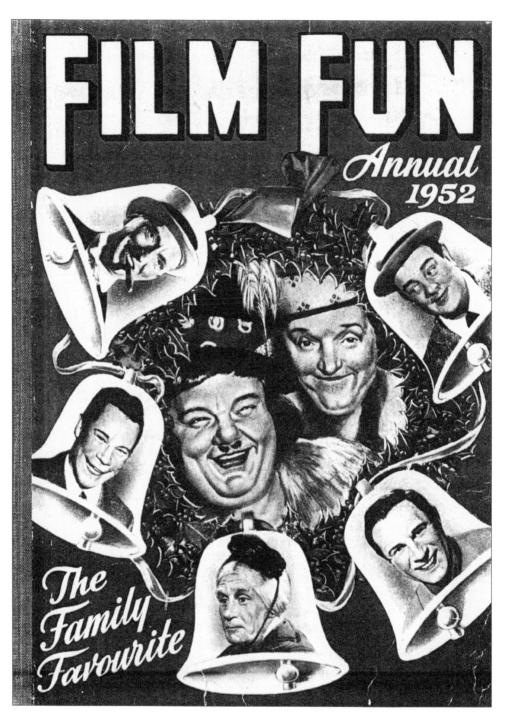

Such was the popularity of Old Mother Riley that the character appeared as a comic-strip heroine in *Film Fun* alongside Frank Randle, Laurel and Hardy, Abbott and Costello and Joe E. Brown. And this illustrator may have been none other than Arthur Lucan's fellow-member of the Savage Club, Harry Riley RI.

Arthur Lucan (Towle) and his wife, Kitty McShane, made at least fifteen films, starting with *Old Mother Riley* in 1937. Others included *Old Mother Riley – Detective* (1942), *Old Mother Riley Overseas* (1943) and the last was *Mother Riley Meets the Vampire* (1952), when he played opposite Bela Lugosi (seen here). Arthur Lucan died in 1954 while performing at the Tivoli Theatre, Hull. He was buried in Hull. Despite commanding £1,000 a week in the thirties and grossing a huge amount from his films, Lucan died penniless.

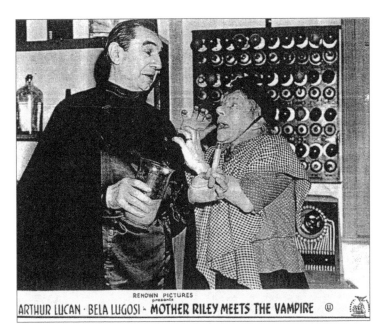

This photograph of the Ventors family is dated 1914 and was taken outside their home in Skirbeck at 1 Glebe Terrace. Front row, left to right: Agnes Victoria (born in 1901, the year that Queen Victoria died), Mr George Ventors (with whip), Dolly (who later married Mr Goldspink), Mrs Ventors (with baby Nellie), Miss Ventors and Joe Ventors (who owned a transport café near Gatwick). Back row: George Ventors (the eldest son, who ran a shop in Boston), Alfred (who died during the First World War when he fell off an aircraft hangar) and Sidney Ventors (who later worked for Van Smirren).

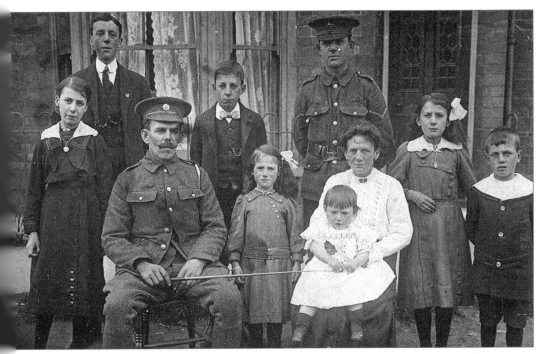

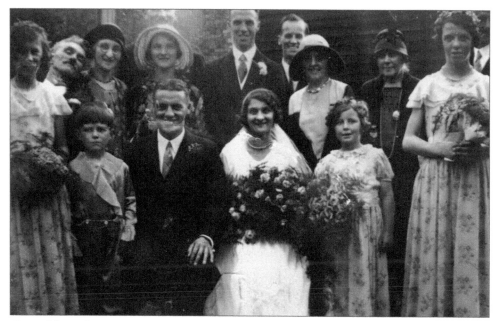

The wedding of Roy Tryner and Miss Maude Salter was in 1930, at the West Street Primitive Methodist church. This chapel, built in 1866 by Benjamin Andrews of Stickford, caught fire on 27 January 1897 and, like the Wesleyan chapel in Red Lion Street, was gutted. It was rebuilt by Mr W. Greenfield, the builder, with much of the finance provided by George Inch, a wealthy Methodist businessman.

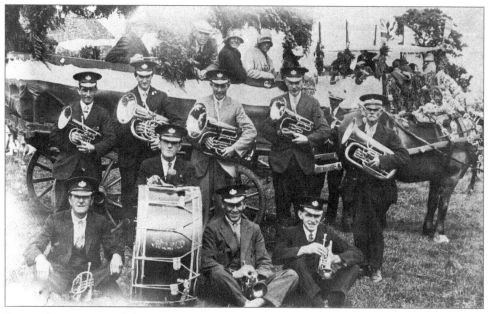

During the twenties and thirties, brass bands enjoyed their heyday. Nearly every village in and around Boston had its own band and they often provided music free of charge. This was the Friskney Brass Band in 1930.

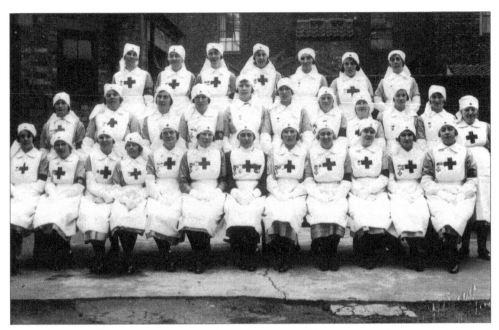

During both world wars, Boston nurses played their part. This group was photographed in April 1932 before their annual WO inspection.

The 1st Allied Airborne Division landed in Arnhem on 17 September 1944 and, after a heroic nine-day stand, only 2,000 men returned of the 10,000 who had landed. Here we see the 1st Air-Landing Light Regiment (RA) marching away from the Stump after a commemorative service on their return from Arnhem. The 1st Airborne Division had been stationed in and around Boston prior to their heroic battle at Arnhem, and Boston was home to the 1st Air Landing Light Regiment of the Royal Artillery.

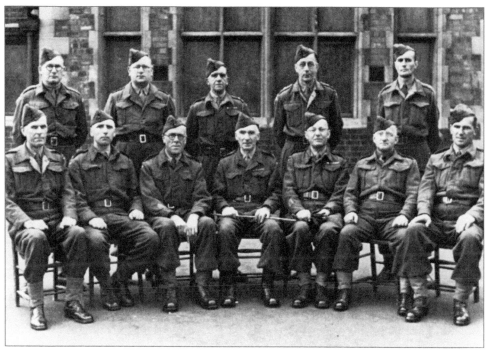

During the Second World War, Boston had several units of Home Guard volunteers. For a while, and especially after Dunkirk, the invasion of England looked inevitable. These were the officers of D Company, photographed outside Boston Grammar School. Back row, left to right: Lt R. Lowther, Lt F.W. Fell, Lt George Evans, Lt H.E. Keightly, Lt R. Ostler. Front row: Lt H. West, Lt A.H. Taylor, Capt L.S. Caswell, Major W. Cheer, Lt J.L. Towell, Lt J. Ward and Lt A. Lealand.

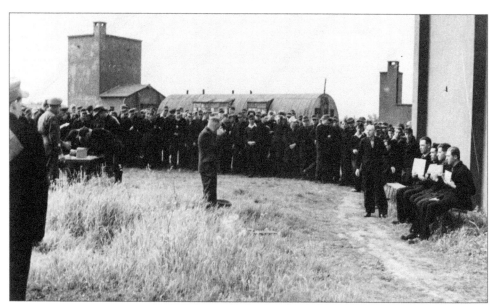

'Fred' Addy (see p. 11) had to photograph a group of German prisoners sent to the Boston area during the Second World War. Sid Addy (his brother) is organising the line-up.

A group of amateur thespians
rehearsing in the mid-sixties.
They called themselves the
Boston Amateur Theatre Group.

One of the annual events in
the Boston calendar is the
Regatta, although these days
it is not held on the same scale
as in Victorian and Edward
times. This fine crew from
Boston Rowing Club were
photographed with their cox
in 1962.

A boat being carried off to the river, Regatta, 1962. Not far from this spot, Matthew Upsall used to charge 2s 6d per hour for the hire of boats.

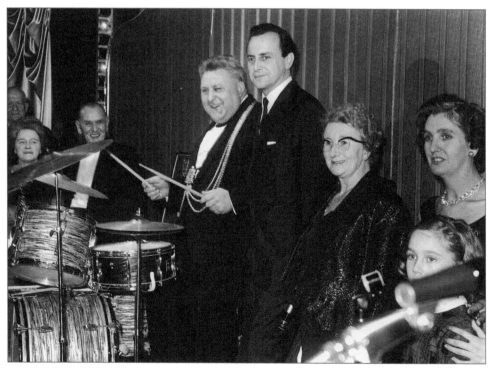

David Jacobs came to open the new Starlight Rooms at The Gliderdrome (see p. 124) on 19 November 1964. He is seen here in the company of Mayor Bert Eyre.

Sir Richard Bernard Body, MP for Boston from 1966–2001, is seen here with his wife, Marian, shaking the hand of Councillor Dick Edgington, with the Conservative agent, W. Bryant, on the extreme right. Sir Richard has always been known for his forthright views expressed in Parliament.

Mayor's Sunday, an annual event when the town's mayor attends a service at St Botolph's and then processes through the town. This picture was taken on Mayor's Sunday, 25 May 1969. Leading the entourage out of the west door of St Botolph's is the mace-bearer, Geoff Denham and, behind him, the Mayor, G.G.A. Whitehead, who was a partner in Roythorne & Co, solicitors, and later became Judge George Whitehead. During the Second World War, Whitehead flew Lancasters and, after being shot down, was one of the few to use the 'Grasshopper Route' to escape back to England. Bruce Veal (with chain), the former Mayor, is between Mayor Whitehead and the vicar.

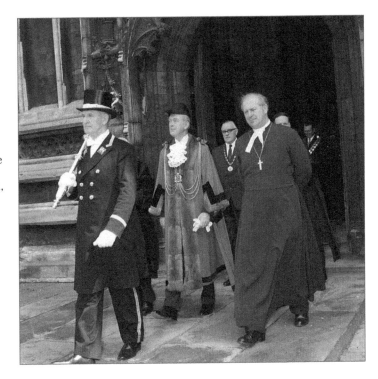

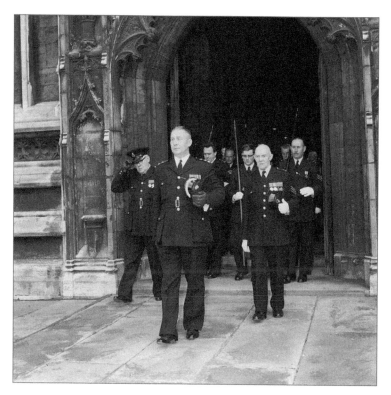

Next in the Mayor's Sunday procession came Superintendent Jack Osgerby (at the front of the group), with three men behind him carrying halberds.

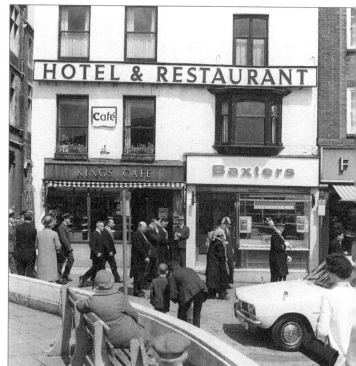

As the Mayoral group went into Market Place, the familiar figure of Ron E. Colley (Town Clerk) can be detected. King Café and Baxter's premises are now a McDonald's burger bar.

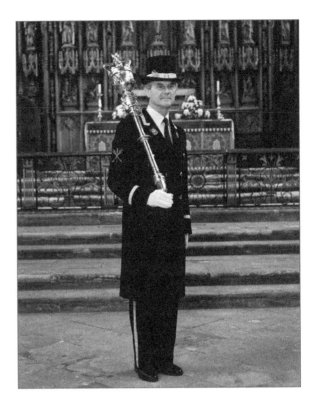

Horace Wright took over as Mayor's Officer in 1971 – a post he held until 1996. Probably his most amusing memory, and certainly his most embarrassing, was on a trip to Boston, Massachusetts, when the American itinerary mixed up the names of the Mayor's Officer and the Mayor.

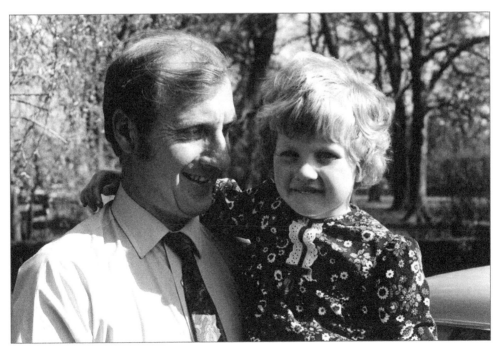

Ray Tinkler, the famous football referee, relaxing with his daughter before going down to London to referee the FA Cup Final at Wembley in 1972.

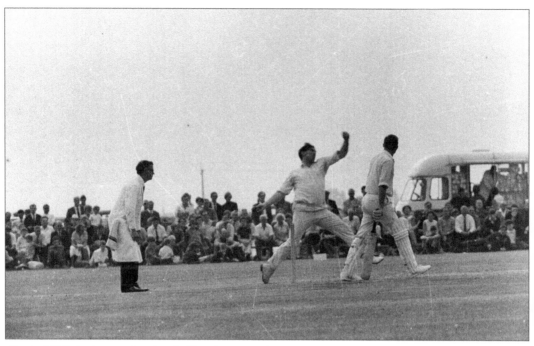

Also in 1972 the Boston Cavaliers held a charity cricket match. That all-time favourite, Fred Truman, was one of the celebrities. He is seen here bowling in his familiar style.

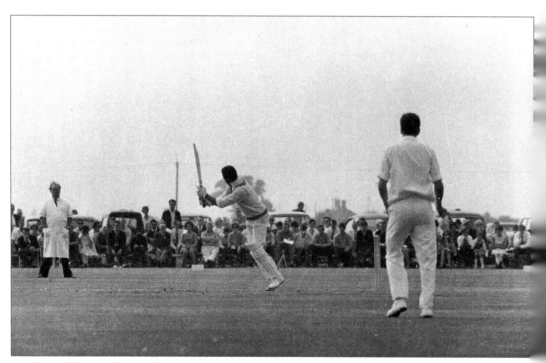

Another celebrity at the match was the great Gary Sobers (now Sir Gary Sobers), batting with ease.

Mention Boston, and Bateman's beers always spring to mind. The Bateman brewery in Wainfleet is currently run by Mr George Bateman (seen here seated fifth from left), who took it over on the death of his father, Harry Bateman, in 1970. George Bateman was educated at Oundle, commissioned in the 17th/21st Lancers, is a fanatical rugby supporter and has been responsible for keeping the family business going at a time when Ridlington's, based at Shodfriars Hall, Boston, could easily have brought about the collapse of the company. He is seen here with some of his employees in 1974. The Britannia pub in Church Street, with its Bateman's advertisement on the side, is one of the most photographed in Britain.

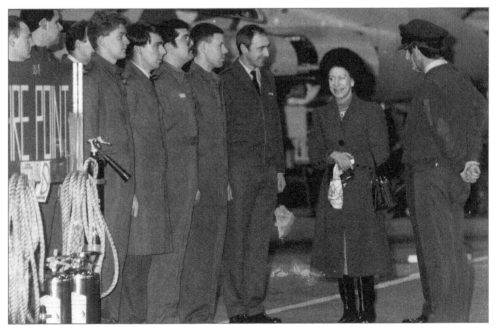

RAF Coningsby's Honorary Air Commodore is HRH Princess Margaret (a post she has held since 1977). She is seen here inspecting Tornado weaponry in May 1985 on a four-hour visit, when Group Captain Mike Elsam was CO in charge of the base.

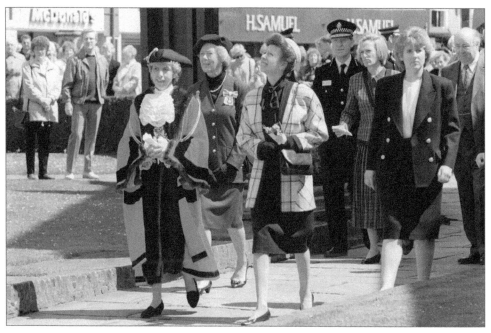

The Princess Royal, accompanied by Mayor Judy Cammack, visited the town in 1995 to mark the 450th anniversary of the incorporation of the Borough of Boston.

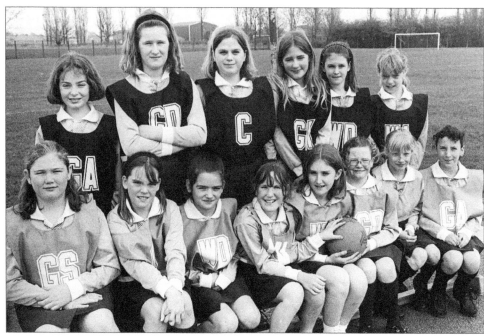

Boston has produced some well-known sporting figures, such as Chris Woods, the ex-England goalkeeper, Karen Corr, the snooker champion, Johnny Cuthbert the boxer, who kept The Mill Inn (as a lightweight, he fought the famous Tommy Farr) and Alison Fisher. I wonder if there are any similar budding talents in this recent photograph of Boston West A and B netball teams?

A BUSY MARKET CENTRE

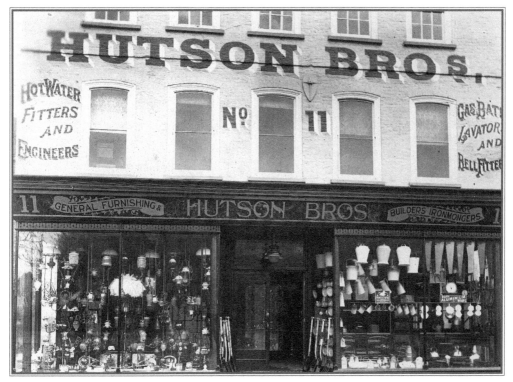

Hutson Bros' frontage, photographed by E.W. Peakome, who worked from 7 Wide Bargate. J.W. Thompson took over Peakome's studio for a time until the Addy brothers purchased it.

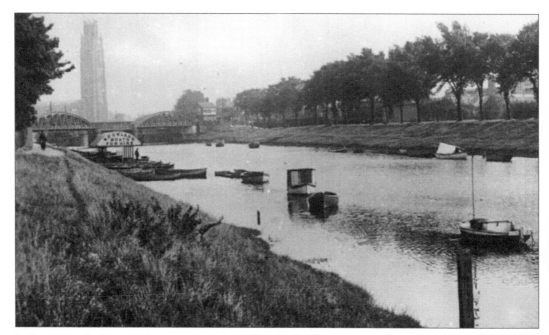

In the 1760s the River Witham was straightened and embanked to reduce the risk of flooding at high and flash tides. The Grand Sluice was built and all the surrounding land became the richest and most fertile reclaimed farming acres in England. This was the view looking down the Witham to the Grand Sluice in about 1920.

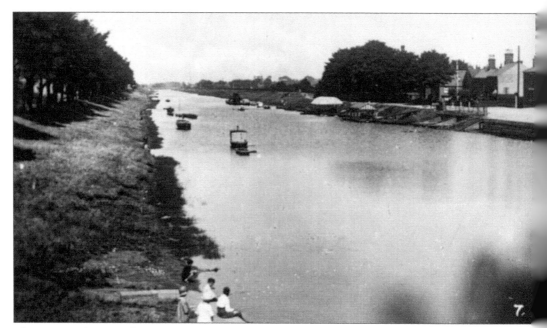

This exercise also opened up the waterway network, which allowed cargo boats and steam-packets to ply the route from Boston to Lincoln and back again on a daily basis. This was the reverse view to the one above, this time looking up the Witham.

Dawson White, wheelwright, blacksmith and agricultural machinist of 78 Wide Bargate, showing off an example of his craftsmanship, *c.* 1890. The name of Dawson frequently crops up in the Boston area, either as a forename or surname. This particular Dawson White was the father of Edward (Ed) White, who founded a garage in 1856.

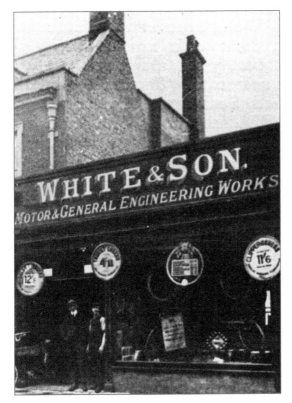

White & Son motor showrooms and general engineering works in High Street, latterly known as Edward White Ltd of Bargate End, *c.* 1910. The company dealt with Vauxhall and Bedford motor vehicles.

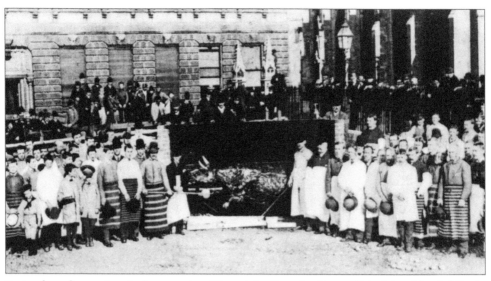

Boston has always risen to the occasion. The celebrations for Queen Victoria's golden jubilee in 1887 included an ox roast in the Market Place. The number of butchers who helped with this event can be clearly seen. Throughout this century Boston has been served well by a plethora of butchers such as Dunmore's, Swain & Dawson, Staines & Crust, Bycroft, Betts and Mountain's.

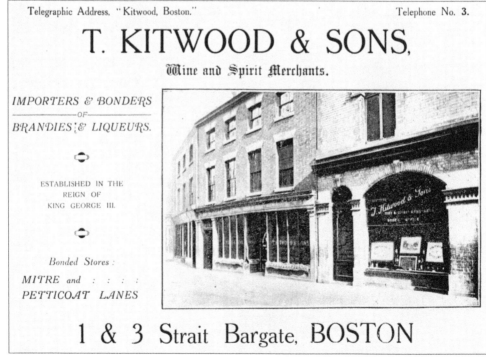

T. Kitwood & Sons, the wine and spirit merchants, was based at 1 and 3 Wide Bargate. The firm's bonded stores were situated in Mitre Lane and Petticoat Lane. This advertisement dates from about 1910.

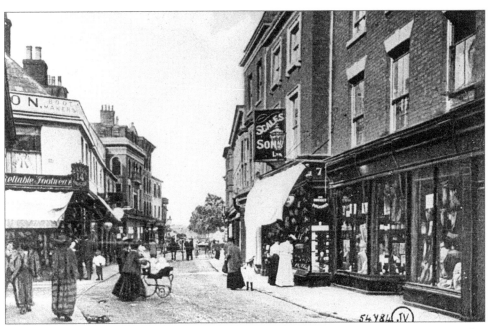

Strait Bargate was always busy. Scales & Son, boot manufacturers, could be found at No. 23 and is seen here in about 1905.

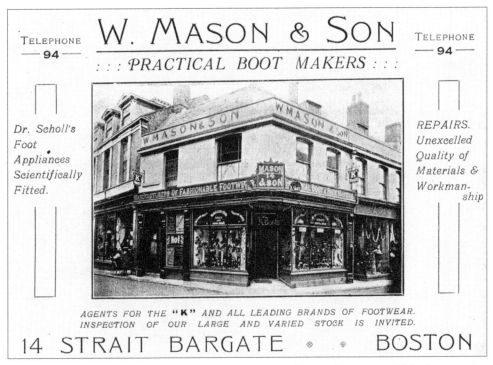

Scales' rivals, W. Mason & Son, who supplied Dr Scholl's 'foot appliances', could be found at No. 14. This advertisement dates from about 1910.

Tom Kitwood, seen here sporting his Kitchener moustache, was Mayor of Boston in 1906 and was made a Freeman of the town in 1931. He was a man of many business interests, not just wines and spirits (see p. 106). When he died, his funeral cortège stretched the length of the town. His name is commemorated in Kitwood School.

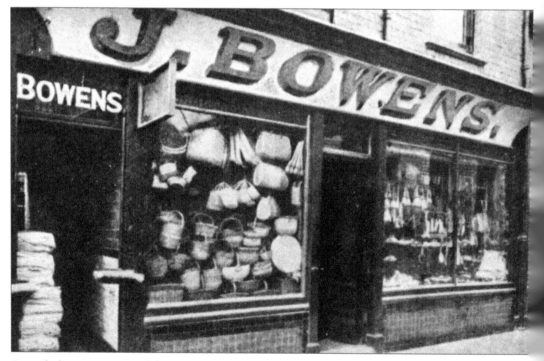

One of the most unusual businesses was Joseph Bowen's brush, mat and basket emporium at 27 Wormgate, seen here in about 1910. Not only did he make the brushes himself, he also made clogs.

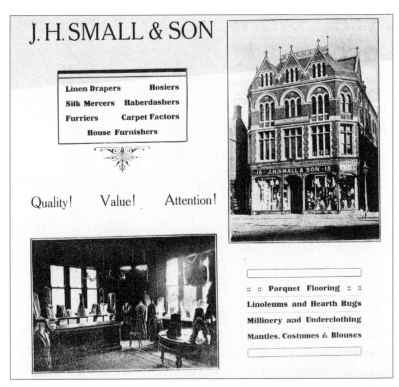

J.H. Small's famous millinery and haberdashery store was based at 15 Market Place. It sold parquet flooring and linoleum, as well as a vast selection of linens and silks, as indicated by this advertisement from about 1910. The premises are currently occupied by the Nationwide Building Society.

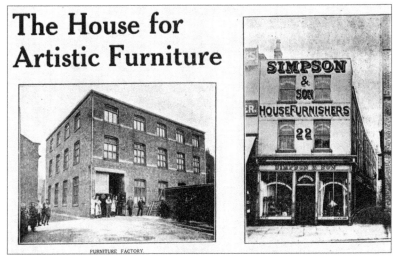

Simpson & Son ('the House for Artistic Furniture') could be found at 22 Market Place, seen here in about 1910. They acted as agents for Nesta, Perco and Somnus bedding (trade names that have long since vanished). John Henry Simpson, who lived at Victoria Villa, Boston West, had built up his business on the back of repairs, re-upholstery and furniture-polishing. When telephones were introduced, this firm was given the prestigious telephone number of Number 2, Boston.

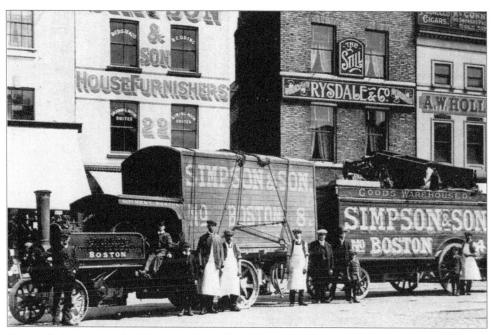

Simpson's shop was wedged between the Leeds & Leicester Book Company (later renamed the 'Rest Value-Givers' – a curious name for a shoe shop) and Rysdale's still. C.W. Rysdale, wine and spirit merchants, also bottled ale and stout, which may account for the name of Still Lane. Here we see Simpson's Aveling steam wagon, used for deliveries and removals.

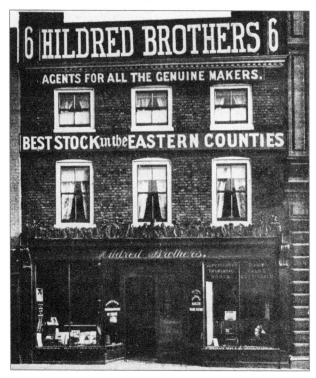

Hildred Bros, of 6 Market Place, sold sheet music and pianofortes. Brothers George and Henry Hildred lived over the shop, pictured in about 1910.

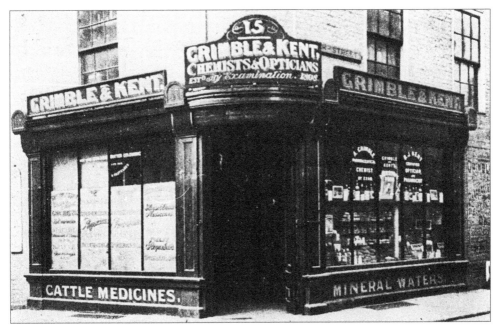

Grimble & Kent – wholesale, retail and manufacturing chemists – at 15 High Street, was started by Albert Grimble, of 63A High Street, and Benjamin John Kent, of 32 Spilsby Road. They soon found that combining the sales of veterinary medicines with their ordinary trade was extremely beneficial to their business. This photograph was taken in about 1910.

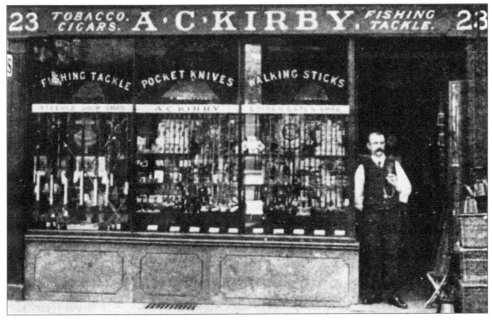

A.C. Kirby was one of the people who benefited from the trade generated by the popular pastime of fishing. But in addition to fishing tackle, he sold tobacco and cigars.

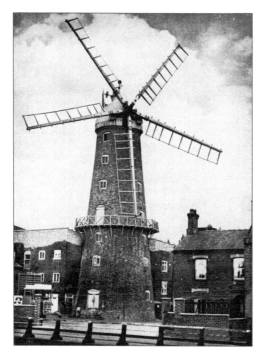

The Maude Foster Mill (named after a wealthy Boston lady and seen here in about 1960) was built for Thomas and Isaac Reckitt in 1819. Indeed Isaac Reckitt, a devout Quaker, began his flour-milling business here. He moved to Hull in 1840 and bought a starch works in Dansome Lane, where he achieved some considerable success manufacturing 'Reckitt's Blue'. The company eventually merged with Coleman's of Norwich, and became known as Reckitt & Coleman.

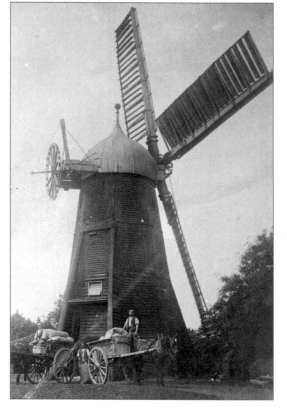

Boston had many mills and there were others in the surrounding area. In an edition of the BBC television programme *Songs of Praise*, recorded in the Stump, Boston was dubbed 'dykes, daffs and windmills'. Skinner's Mill, in nearby Freiston, was built in about 1827 and ceased working in 1924. The sails were removed only a few years ago. It has since remained a derelict shell.

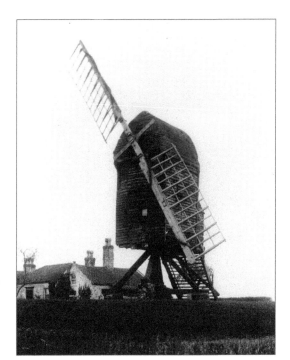

Stevenson's post mill at Friskney Toffs, *c*. 1900. This was yet another casualty of changes in milling practices. Like so many other post mills, which were of wooden construction, it soon fell into disrepair. The more substantial tower mills, which were made of brick, stood a better chance of survival.

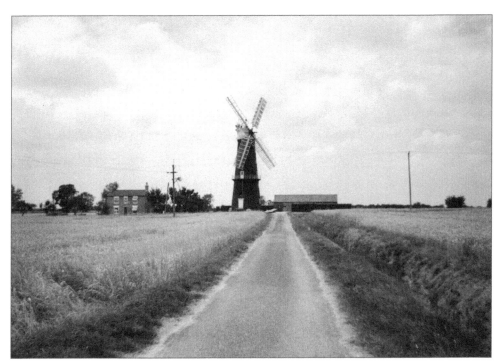

Sibsey Trader Mill has survived. It was built in 1877 by Saunderson of Louth. It worked until 1954, when it was allowed to become derelict, but in 1970 it was restored and in 1981 became fully operational again.

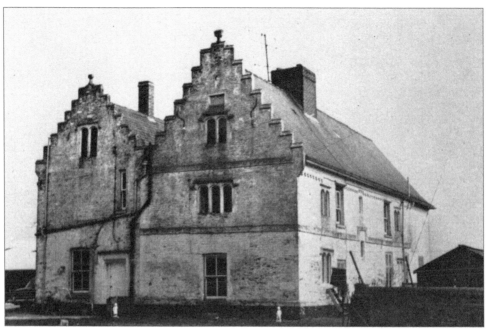

One of Boston's most extraordinary claims to fame is associated with White Loaf Hall, near the old sea bank in Freiston. It is said to be here that the first ever white loaf was baked in England. On the first of its two stepped gables is a stone shaped in the form of a loaf of bread, with the date 1614. This is such an extraordinary claim that it might just be true. Prior to 1614 brown bread was the staple diet of every Englishman.

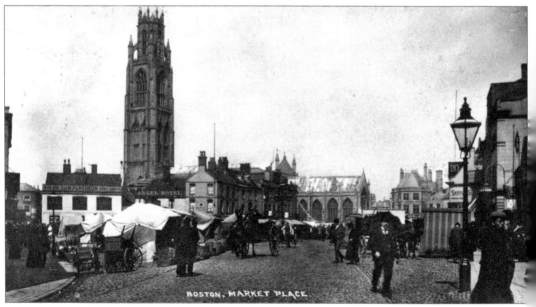

BOSTON, MARKET PLACE.

Market days in Boston are Wednesday and Saturday. In days gone by there was always a plentiful supply of corn, poultry, butter, eggs and freshwater fish. This photograph was taken in about 1912.

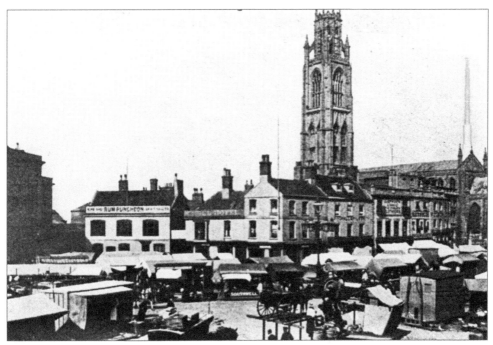

In this further view of the Market Place, this time taken in 1905, it is easier to see The Rum Puncheon pub (to the left of the photograph), which was built on the site of the house where John Foxe (1516–87), author of *The Book of Martyrs*, was born. There are several copies of Foxe's famous book, which at one time ranked next in influence to the Bible and *Pilgrim's Progress*, in St Botolph's library (just above the porch). Incidentally, John Foxe was a great friend of John Taverner (1495–1545), the musician and composer of church music, who is buried beneath the tower of the Stump.

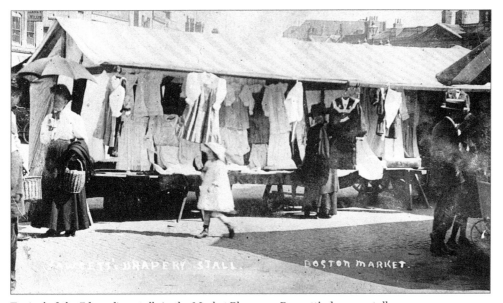

Typical of the Edwardian stalls in the Market Place was Fawcett's drapery stall.

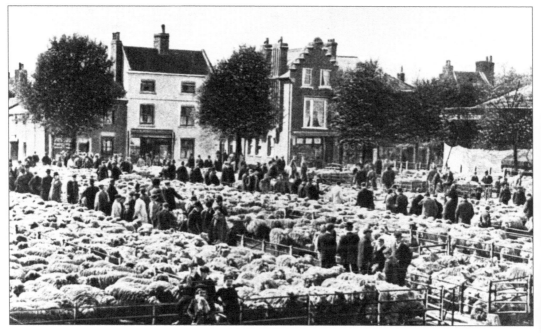

Although there were sheep markets on Wednesdays in both spring and autumn, at the annual Sheep Fair, held on 4 May, as many as 30,000 sheep could change hands in a single day. This image shows the 1905 fair.

The post office in Wide Bargate (centre) was opened in December 1907 by the then Postmaster-General. O the other side of the road, on what was known as Boston Green, lay the two Russian guns captured in th Crimean War and brought back to Boston.

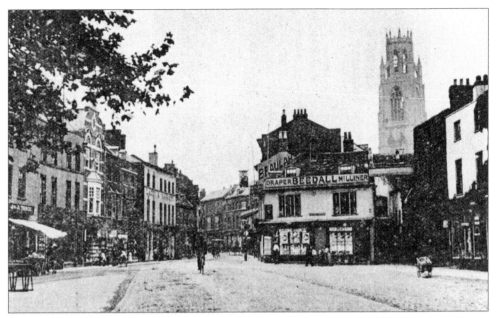

Lacey & Garrett's emporium is in the centre of this picture, taken in about 1910. Beedall's millinery business is on the right, with Beaulah's grocery business (specialising in importing tea and coffee) just beyond it.

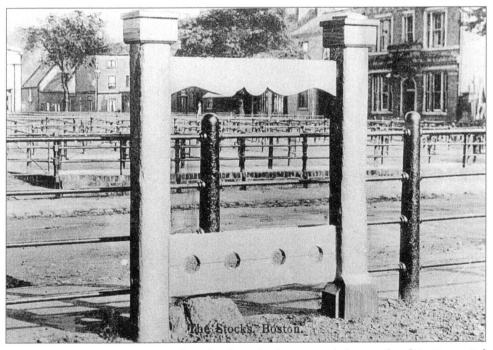

The stocks on Bargate Green were allowed to decay but have recently been replaced, just to remind the public that this sort of punishment might return! The sheep pens behind the stocks, were dismantled at about the same time that John Adams Way was built. (Lincolnshire Library Service)

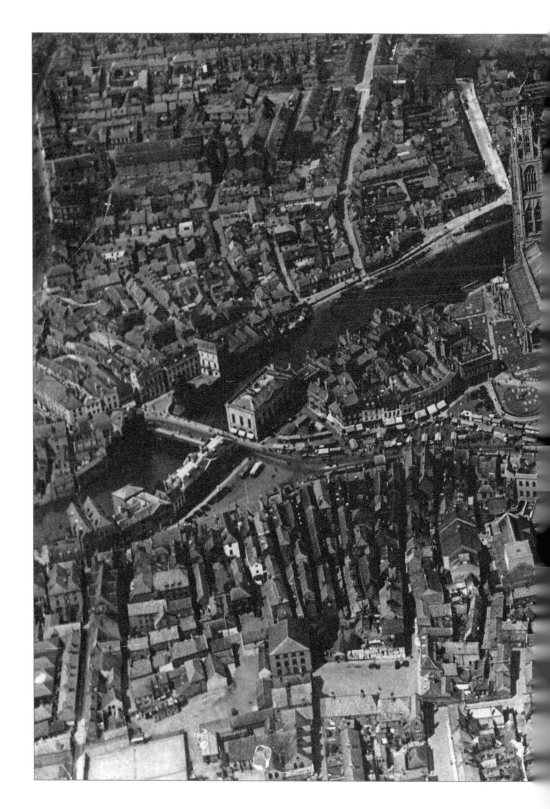

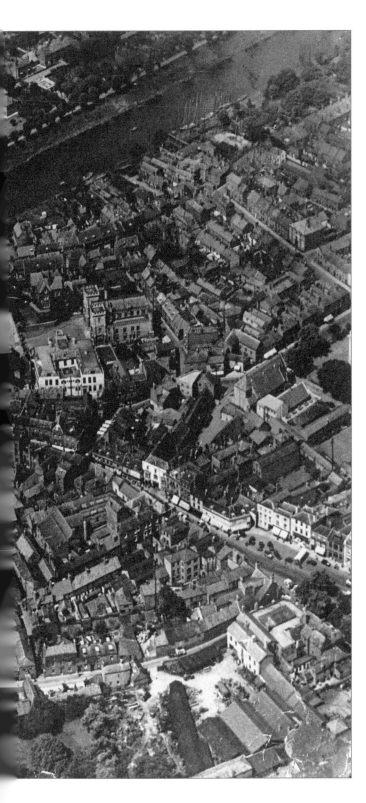

This aerial view of Boston in the thirties (the photograph was taken on Market Day) reveals just how much the town has changed. Vast areas of old buildings have been swept away for redevelopment.

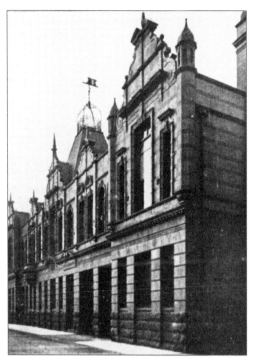

When Boston's Municipal Buildings were opened on 16 June 1904 by Alderman Joseph Cooke, there was an official programme to mark the event, which comprised a reception at the Assembly Rooms, a civic procession, luncheon at the Drill Hall (Main Ridge), tea for the children and the issue of 5,000 commemoration medals (one presented to every pupil attending an elementary school in Boston). Businesses and private houses were requested to hang flags and banners, the bells of St Botolph's rang, all traffic was banned from the centre of town and Boston's schools were given a day's holiday. The Municipal Buildings were used by the Corporation, they housed the Library, were the Police headquarters, and accommodated the Fire Brigade and the School of Art. The same buildings are currently used by the present Borough Council.

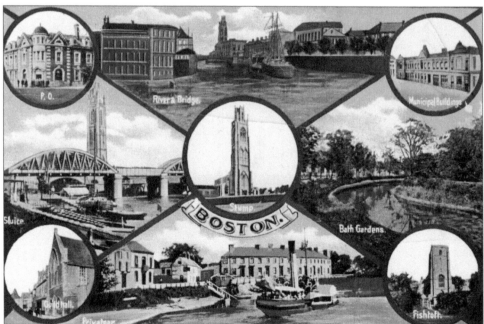

In the golden age of postcards, when people sent literally hundreds of cards a year, this composite card of Boston was popular. Dated 13 February 1913, this one was addressed to a Mr Harding, of Frampton Villa, St Neots, and said 'Dear Edward, you will see I have arrived in Boston. N. and I went to chapel. It's a lovely organ. We are going for a walk and to Mr Enderby's for tea. It is a most glorious day here. Love, Ethel.'

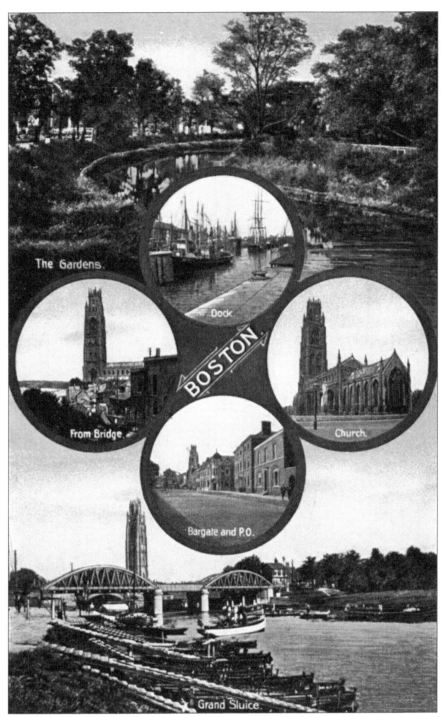

The Gardens. Dock. BOSTON From Bridge. Church. Bargate and P.O. Grand Sluice.

In this postcard of about 1905, which is also a composite, the sender has written the words of his simple message backwards to fool the postman. These postcards are highly collectable and are increasing in value as deltiology, the third largest hobby in Britain, becomes more fashionable.

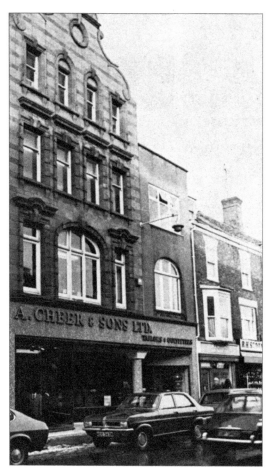

The firm of A. Cheer & Sons Ltd was founded in 1876 by Albert Cheer, who started his tailoring business in Emery Lane and South Street. In 1878 the Emery Lane shop transferred to large premises in West Street and the Cheer family of seven lived above the shop until 1897, when they purchased a house in Kirton. The Louth branch was opened in 1894 and the Holbeach branch in 1900. When Albert Cheer died, his business was continued by two of his sons, Walter and Tom. There were other branches at Alford and Brigg but these were sold and the Louth branch, in the Market Place, was also sold in the seventies. For over 100 years this firm has served the men and boys of the county in the ever-changing world of men's fashions.

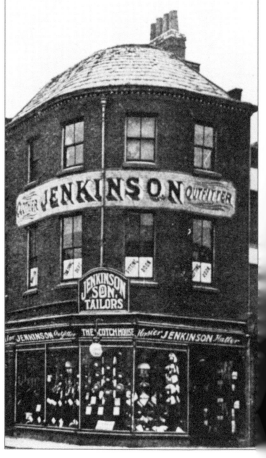

The other tailor in Boston was William Jenkinson & Son, who occupied this corner building in the Market Place. Jenkinson, who lived in Frampton Place, was succeeded by John Chambers. This photograph dates from about 1910.

The combination of Mr W. Lacey of Louth and Mr R. Garratt of Grantham was strong enough to buy the firm of Messrs Thorns & Co, of 19 and 21 Strait Bargate, Boston, in 1901. They retained the services of the then manager, Mr Page, and sold an assortment of carpets, linos and fancy goods on the ground floor, millinery and mantles on the second and a selection of furniture on the top floor.

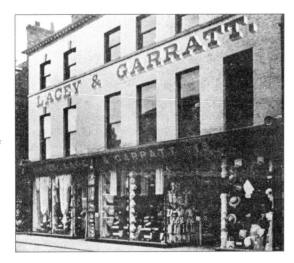

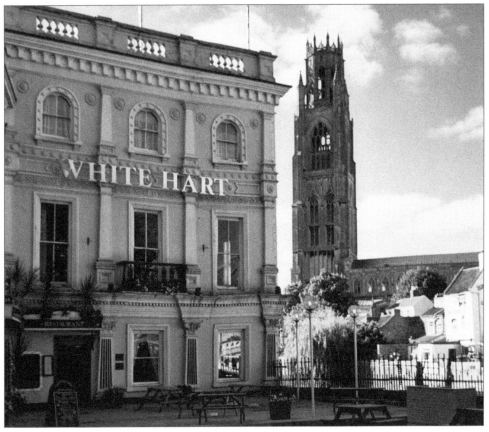

The present White Hart Hotel replaced an older inn with the same name which also used to be situated in High Street and was built on the site of the old Carmelite Friary. Mr Cropley, a local carrier, whose van brought farmers and their wives to market from Sutterton and Algakirk, remembered market days as 'jolly affairs'. It was the introduction of his Model T Ford 14-seater that cut the journey down to about an hour. (The old horse and wagon used to take at least two hours!)

Reuben Salter (1864–1958), the socialist alderman, who was Mayor of Boston in 1929, was awarded the freedom of the town in 1954. A newsagent by trade, he achieved much goodwill when he visited Boston, USA, in the year of his mayoralty, meeting and befriending the famous Mayor Curly. Salter was dubbed 'Little Reuben Salter' by the American press, who took him readily to their hearts. There is an amusing anecdote of Salter's visit to the States. When he was being driven in the official car as part of the cavalcade and, as he tried to throw some flowers back to them, he caught the white top hat of the man sitting in front of him and sent it for six. The hat belonged to none other than the famous newspaper magnate William Randolph Hearst! The rapport between Boston, Lincolnshire, and Boston, Massachusetts, has continued to this day. Apart from being the first socialist Mayor of Boston, he was also a member of the Oddfellows, a Primitive Methodist lay preacher and an occasional journalist. Like Herbert Ingram (see pp. 80–1) before him, he was concerned with providing quality drinking water for Boston and was responsible for the installation of the Fordington Water Scheme.

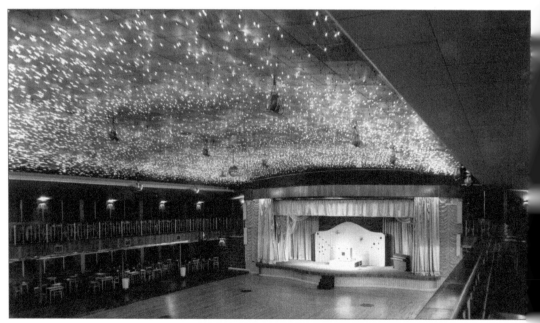

Mention the Gliderdrome, Boston, and all sorts of memories probably come flooding back. This was the opening of the Starlight Rooms in 1964. But, in the fifties, all the big names played here: Joe Loss, Jack Parnell, Eric Delaney, Ted Heath and that versatile pianist Winifred Atwell. Otis Reading probably attracted the biggest crowd but other stars who appeared included Brenda Lee, Donovan, Tom Jones, Marty Wilde, Jimi Hendrix, T-Rex and Gerry and the Pacemakers. As the name implies, it was a roller-skating rink in the thirties until the Malkinson family purchased it in 1936.

Marty Wilde appeared at the Starlight Rooms on 1 February 1964.

Donovan was on stage on 4 September 1965. Ted Eaglin (one of the bouncers) had to prevent the fans from mobbing the star by lying on the stage!

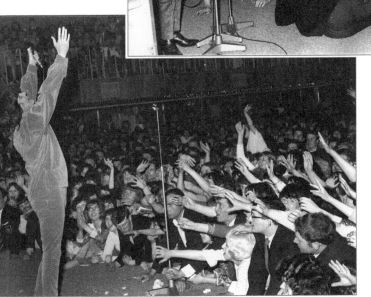

P.J. Proby at the Gliderdrome, 1 May 1965.

This book is dedicated to my father, George Alfred Cuppleditch (1917–94), who was born in Frampton, and lived much of his young life in and around Boston. During the Second World War, he joined the Royal Signals and was recruited by SOE. After the war he served as a colonial civil servant in Somaliland, Singapore and Hong Kong. On his return to England he became Mayor of Louth (twice) and, after his death, a road was named in his honour - Cuppleditch Way.

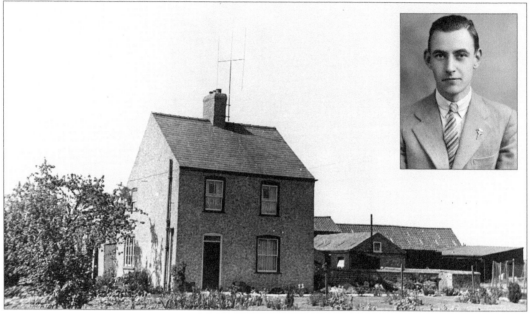

This is the house between Frampton and Wyberton where my father (inset) was born on 27 May 1917. It was a typical example of so many small-holdings in the Boston area. This picture was taken in 1957.

ACKNOWLEDGEMENTS

I would like to thank the following people for all their help and information in making this book possible:

Derek Addy, Gary Atkinson, David Bolland, Peter Dennis, Ted Eaglen, Mrs Kate Faulkner, Tim Hartley of the *Boston Standard* Group, the late Brian Howe, Richard Hutson, Simon McElwain, Mr and Mrs Malkinson, John Middleton, Lorraine North of Boston Borough Council, Linda Roberts of the *Grimsby Evening Telegraph*, Mark Rudkin, James Sutcliffe of Boston Port Authority, Jim Tryner, Chris Volley, James Wiles, Horace Wright and Louth Secretarial Services for typing the manuscript carefully. Thanks also are due for the use of pictures from the Local Studies Section, Lincoln Central Library, which are reproduced by courtesy of Lincolnshire County Council, Education & Cultural Services Directorate.

ROLL OF HONORARY FREEMEN OF THE BOROUGH OF BOSTON, 1901–1999

18 May 1901
Lance Sergeant Frank David
 Emery
Corporal Oliver Cooper
Lance Corporal Charles W.
 Crawley
Lance Corporal John Baxter
 Kirkby
Private Ralph Kirkby
Private Meaburn Staniland
Private Cyril J. Mawson

10 November 1902
Private Bertrand Beulah
 Cheshire

1 June 1920
Robert William Staniland

31 March 1931
Alderman Tom Kitwood, JP

14 May 1945
Alan Forbes (Boston,
 Massachusetts)

30 October 1950
Edward Arthur Bailey

27 September 1954
Reuben Salter

26 September 1955
Charles Henry Wing

16 October 1961
John Henry Mountain

16 May 1963
Royal Air Force Station,
 Coningsby

16 November 1964
Alfred Chester

30 September 1968
Cyril Louis Hoffrock Griffiths

6 March 1973
Alderman Arthur Lealand

21 April 1972
James Parkin Roe

20 June 1981
The Second Battalion The Royal
 Anglian Regiment

21 April 1986
Lyn Ellis

26 April 1991
Leonard Medlock

29 January 1994
HMS *Cottesmore*

30 October 1995
Reginald Geoffrey Manning
 Moulder

23 February 1998
Margaret Haworth, JP

15 March 1999
James Robert Howes

MAYORS OF THE BOROUGH OF BOSTON, 1900–1999

William Turner Simonds	1900	A. Cooke Yarborough	1918	A.C. Rysdale	1936
William Turner Simonds	1901	William Porter	1919	Jabez H. Mountain	1937
Joseph Cooke	1902	Edward Richardson	1920	John R. Mowbray	1938
Joseph Cooke	1903	John Beaulah	1921	H. Percy Clark	1939
William Turner Simonds	1904	J.W. Pinder	1922	H. Percy Clark	1940
Henry Barron Clarke	1905	Charles H. Wing	1923	J.G. Wrigley	1941
Tom Kitwood	1906	Charles Day	1924	George H. Bird	1942
Tom Kitwood	1907	A.K. Turner	1925	Arthur Bradley	1943
G.S.W. Jebb	1908	James Tait	1926	John Mountain	1944
G.S.W. Jebb	1909	James Tait	1927	Wm E. Anderson	1945
James Eley	1910	E.A. Bailey	1928	T.M. Moffatt	1946
James Eley	1911	Reuben Salter	1929	G. Vernon Clark	1947
Millson Enderby	1912	William H Lunn	1930	E.C. Stanwell	1949
Charles Lucas	1913	Frederick Peck	1931	J.W. Mowbray	1950
Charles Lucas	1914	Charles Wm Fleet	1932	E.C. Stanwell	1950
Charles Lucas	1915	John H. Tooley	1933	J.P. Roe	1951
James Eley	1916	John S. Towell	1934	Alice S. Johnson	1952
A. Cooke Yarborough	1917	Stephen Wain	1935	E.H. Porcher	1953

Wm A. Midgley	1954	Norman McClement	1971	Alfred Adolf Goodson	1985/6
E.A. Arnold	1955	Norman H. Hughes	1972	James Thomas	
Bertha M. Roe	1956	John J. Parker	1973	McGregor Alcorn	1986/7
C. Valentine	1957	Peter Ellice Paine JP	1973/4	Richard Frank Harlow	1987/8
C. Valentine	1958	Peter Ellice Paine		Herbert Arthur Allen	1988/9
E.B. Willis	1959	MBE JP	1974/5	Reginald Geoffrey	
J.H. Dell	1960	John Joseph Parker	1975/6	Manning Moulder	1989/90
Thos. B. Balderston	1961	Frederick Myatt	1976/7	Alexander Amos	
Ralph H. Jenkin	1962	John William Addelsee	1977/8	Cutting	1990/1
Alfred Adolf Goodson	1963	Margaret Haworth JP	1978/9	Ernest Albert Napier	1991/2
Bert Eyre	1964	John Hildred	1979/80	Joyce Nora Dobson	1992/3
Reginald G.M. Moulder	1965	John Charles Wright	1980/1	Keith Dobson JP	1993/4
N.M. Middlebrook	1966	Cyril Fovargue	1981/2	Clive Marshall	1994/5
C.H. Atterby	1967	Robert Verdun		Judith A. Cammack	1995/6
Bruce J. Veal	1968	Marriott	1982/3	Charles Albert Tebbs	1996/7
G.G.A. Whitehead	1969	John Harold Wallis	1983/4	Fred E. Gilchrist	1997/8
F. Alan J. Foster	1970	Thomas William North	1984/5	Alan Day DFC JP	1998/9

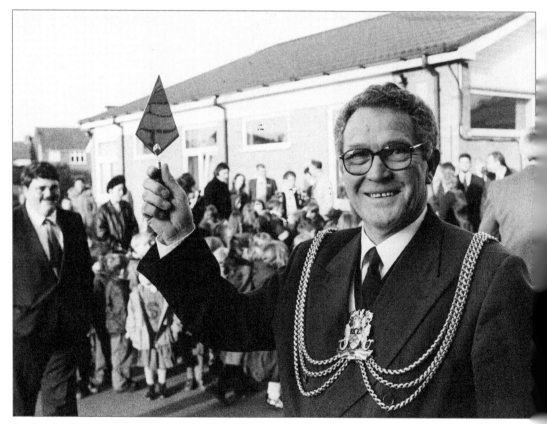

Just as the Mayor, Mr Simmonds, cut the first sod of Boston dock in 1882 (see p. 29), so Charles Alber Tebbs, Mayor 1996/7, followed suit with the new sports hall at St Thomas's School.